IMAGES
of America

THE DETROIT
ATHLETIC CLUB

1887–2001

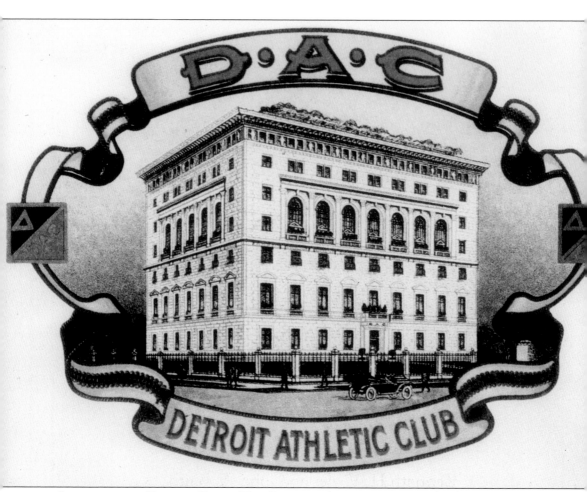

STANDING THE TEST OF TIME—THE DETROIT ATHLETIC CLUB. This beautifully rendered early art emblem depicts the DAC's new Madison Avenue clubhouse in all its glory. The stately clubhouse, designed by famed Detroit architect Albert Kahn, has stood on the same spot for more than 85 years, carrying forward the grand traditions begun in 1887 by a group of prominent Detroit men who formed the original club on Woodward Avenue. Over time, this artwork has become somewhat synonymous with the DAC. It was dubbed the DAC "cigar art," because the image was originally created for use on cigar boxes produced for members. It is still seen today on Club menus, invitations, and various programs at the DAC. The fence shown surrounding the newly completed 1915 clubhouse grounds was never constructed.

IMAGES
of America

THE DETROIT
ATHLETIC CLUB

1887–2001

Kenneth H. Voyles and John A. Bluth

ARCADIA

Published by Arcadia Publishing
Charleston SC, Chicago IL, Portsmouth NH, San Francisco CA

Printed in the United States of America

Library of Congress Catalog Card Number: 2001092771

For all general information contact Arcadia Publishing at:
Telephone 843-853-2070
Fax 843-853-0044
E-mail sales@arcadiapublishing.com
For customer service and orders:
Toll-Free 1-888-313-2665

Visit us on the Internet at http://www.arcadiapublishing.com

This is for Sue, Elena, and Ethan
KHV

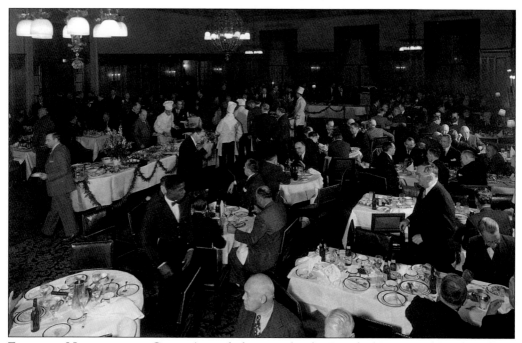

ELECTION NIGHT AT THE CLUB. Annual elections for the Board of Directors have long been important events at the DAC—this is when new Club presidents are selected. An election-day tradition is the serving of a free prime rib dinner to all members—who must personally come to the Club to cast their ballot. Here, members not only enjoy the repast but clearly evident are numerous bottles of Pfeiffer Beer, one of Detroit's famous breweries.

CONTENTS

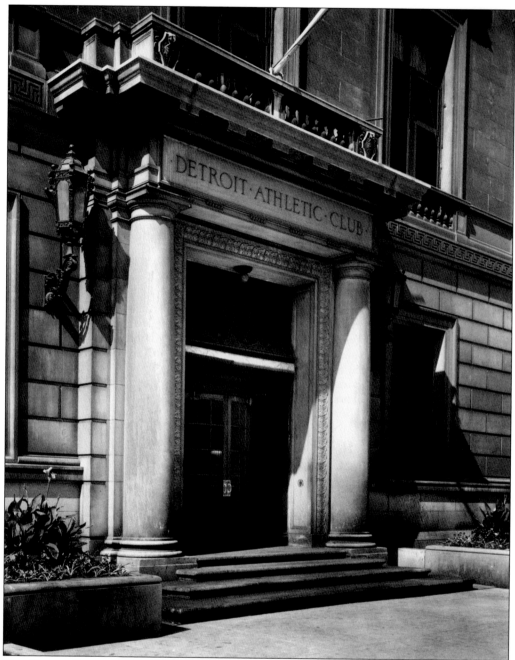

THE GRAND FRONT ENTRANCE. The DAC's Madison Avenue clubhouse features this beautiful front entrance, a passageway through which numerous presidents and kings have entered the Club. The revolving door and curved outdoor doors are original to the clubhouse and are wonderfully framed by two beautifully craved marble columns capped with a cornice and balcony above.

ACKNOWLEDGMENTS

This book was a joint effort between Ken Voyles and John Bluth utilizing the photo files of the Detroit Athletic Club's award-winning magazine, the *DAC News*, as well as other departments at the DAC and several important sources in Detroit. Among those who need thanks are the staff of the Burton Collection of the Detroit Public Library, the staff of the Walter Reuther Library at Wayne State University, and the archives of Albert Kahn & Associates. Voyles, a longtime journalist and current editor and publisher of the *DAC News*, conceived the project and led its production. Bluth, the magazine's former editor and an individual who can rightly be considered the Club's historian, contributed his extensive knowledge of the DAC. We were also supported in this publication by the staff of the *DAC News*, and other departments at the Club, including Membership, Athletics, and the Manager's Office. No acknowledgment would be complete without our thanks to the DAC's Board of Directors and the Communications Committee, who supported this project throughout its conception.

Ken Voyles

INTRODUCTION

Many organizations have graced the scene during Detroit's 300 years as a city, but few have had the impact on the community as much as the Detroit Athletic Club (DAC). Like a boulder in the midstream of a river, the DAC has shaped more than 100 years of Detroit history.

The original club, founded in 1887 by a group of privileged young men under the spell of amateur athletics sweeping the country at the time, was later reborn in 1913 by a group of the city's prominent automotive and industrial leaders. They reorganized the DAC and commissioned famed architect Albert Kahn to design the magnificent six-story clubhouse that stands today in the center of the city's theatre and sports district.

The original DAC clubhouse, which no longer exists, was located just south of the cultural heart of Detroit along Woodward Avenue, where today one can find the Detroit Institute of Arts, the Detroit Public Library, and the campus of Wayne State University.

That first facility was designed primarily as an athletic center with a cinder running track, baseball diamonds, bowling alleys, and later on a full gymnasium. Some of the early DAC members were founders of the AAU (Amateur Athletic Union), an organization that dominated amateur athletics in this country well into the 20th century. Many of these same athletes and first club members would later be instrumental in the creation of the current Detroit Athletic Club.

Athletics at the Woodward Avenue club focused on team sports, particularly baseball, football, track and field, and even cricket. And the club produced many fine athletes, including Harry Jewett, Fred Ducharme and John Owen. As the 19th century rolled into the 20th, the DAC fell on hard times—many of its young members, some of whom went off to fight in the Spanish-American War, began to lose interest in amateur sports and to focus instead on business development and the growing automobile industry.

The first club nearly closed down, save for the efforts of John Kelsey, who personally funded it for a number of years. When the new clubhouse opened in April of 1915, it was the culmination of the careful plans and dreams of more than 100 prominent Detroiters, many of who were automotive pioneers. Names like Chalmers, Jewett, Kelsey, Joy, Lodge, Metzger, Hughes, Navin, and Scripps will forever be associated with the Club's 20th century rebirth and its place as a home to industrial titans.

Traditionally, the new DAC was born on January 4 of 1913, when 109 leading citizens of Detroit met at the Pontchartrain Hotel to sign articles of association and organize a framework of committees to start the club on its way. It made sense for the new club to carry forward the name and even traditions of the first group—Henry Joy, who called that meeting together, and Kelsey (president of the old club for many years) worked diligently to reach that milestone date. Nearly a year before the meeting, men like Abner Larned, Jewett and Charles Hughes clamored for the

organization of a new club catering to business and community leaders. By the end of 1912, an organizational structure was in place, leading to that 1913 gathering.

The group hired Albert Kahn to design the new clubhouse. So spectacular was the interior beauty of Kahn's Madison Avenue building that the official opening in 1915 became a major milestone in Detroit history. The DAC, which wrote a major national magazine at the time, "is an expression of Detroit's greatness. . . . Nowhere but in Detroit could it be done." In the ensuing 85 years, the Club and its clubhouse have stood the test of time—no major structural overhauls to the building have been needed. Membership remains strong with more than 4,000 current members in various categories, including 3,000 voting resident members. Today the DAC membership truly reflects the diversity of Detroit as it enters its fourth century as a city.

Several years ago the Club began spending millions to restore the fine art details of the interior rooms, shining a fresh light on the greatness of what many saw on that day in 1915 when the clubhouse originally opened its doors. Over the years the Club has been honored as one of the finest in the nation, and countless community leaders have strolled its halls, swam in its pool, eaten in the fabulous Grill Room, or attended a gala black-tie event within the grandeur of the Main Dining Room. Being a hub of greatness in a great city, the DAC has seen its share of the famous, from U.S. presidents to kings, from aviators and war heroes to athletes and entertainers.

Tradition is a watchword at the DAC—business, social, athletic—with succeeding generations in many families taking membership with the Club, holding dear the memories of events and activities in the clubhouse and creating a sort of "corporate memory."

First and foremost, the DAC remains an athletic club. It has always been home to world class Olympic and amateur athletes as well as professionals, with the clubhouse playing host to regional, national, and international tournaments and exhibitions of all types, from boxing and fencing to swimming and squash. Today members swim in the pool where Johnny Weissmuller set an indoor record. They play basketball in a gymnasium where amateur boxing championships have been held and where many an athlete (and entertainer) has graced the Club. They compete with international squash players or just enjoy a friendly game of handball or racquetball. They stay in a room where world-renowned golfer Walter Hagen lived for many years, and they routinely enjoy the company of great coaches and local athletes from Detroit's professional teams and Michigan's fine college programs.

While many of Detroit's institutions have come and gone, the Detroit Athletic Club remains a rock solid force in the city where it was born, providing a center for community leadership and a focal point around where many important decisions have been made. As many in Detroit already realize, the Detroit Athletic Club has been and remains the rock-solid center for the city's leadership.

Past Presidents of the DAC

1913–16 Hugh Chalmers	1960 L.L. Colbert
1917–18 John Kelsey	1961 Raymond T. Perring
1919 Henry B. Joy	1962 Semon E. Knudsen
1920 Abner E. Larned	1963 N.J. Fredericks
1921–22 W.E. Metzger	1964 Arnold D. Freydl
1923 Walter O. Briggs	1965 Frank E. Kenney
1924 Harry M. Jewett	1966 Edwin O. George
1925 Frank J. Navin	1967 Jervis C. Webb
1926 H.M. Nimmo	1968 Nathan B. Goodnow
1927 Arthur T. Waterfall	1969 Lynn A. Townsend
1928 B.F. Everitt	1970 William A. Prew
1929 Peter J. Monaghan	1971 M. Frank McCaffrey
1930 Charles T. Fisher	1972 Frank A. Colombo
1931 DuBois Young	1973 Fred H. Rollins Jr.
1932 Herbert B. Trix	1974 Frederick Colombo
1933 William M. Dillon	1975 John J. Riccardo
1934 William G. Lerchen	1976 C. Boyd Stockmeyer
1935 K.T. Keller	1977 H. James Gram
1936 Edward F. Fisher	1978 Ralph J. Ladd
1937 Henry F. Vaughn	1979 Donald H. Mitzel
1938 Charles T. Bush	1980 Rodney C. Linton
1939 William S. Knudsen	1981 David C. Clark
1940 Martin C. Callahan	1982 Rodkey Craighead
1941 Thomas J. Bosquette	1983 Daniel J. Kelly
1942 John A. Fry	1984 Donald A. Lindow
1943 Carl Breer	1985 Robert D. Lund
1944 M.E. Coyle	1986 Ronald J. Kowalski
1945 Arthur W. Winter	1987 Earl R. Boonstra
1946 C. David Widman	1988 Ivan Ludington, Jr.
1947 D.S. Eddins	1989 B.A. (Bud) Bates Jr.
1948 Harvey Campbell	1990 Robert L. Richardson
1949 H. Lynn Pierson	1991 John R. Edman
1950 Ben R. Marsh	1992 Charles M. Bayer
1951 John R Davis	1993 F. William Manion
1952 Thomas H. Keating	1994 W. George Bihler
1953 David A.Wallace	1995 William A. Morrow
1954 William A. Mayberry	1996 John C. Prost
1955 J. King Harness	1997 Douglas J. Rasmussen
1956 Joseph E. Bayne	1998 Thomas R. Quilter III
1957 Peter J. Monaghan	1999 Terrence E. Keating
1958 Charles T. Fisher Jr.	2000 Thomas E. Wolfe
1959 Walker L. Cisler	2001 Charles H. Nicholl

One

THE ORIGINAL DETROIT ATHLETIC CLUB

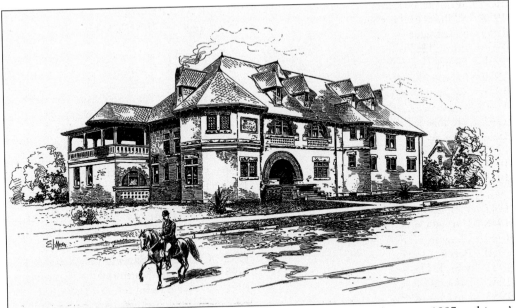

THE FIRST REPRESENTATION OF THE DAC'S FIRST CLUBHOUSE. This is an 1887 architect's drawing of the clubhouse created by the firm of Gearing and Stratton. In addition to being an architect, J.V. Gearing was a founding member of the club. He was also the Wayne County Notary before whom the 29 founders appeared, on April 5, 1887, to present their Articles of Association, officially launching the DAC. Gearing's company received approval from the club Board of Directors to build a $12,000 clubhouse in August of 1887.

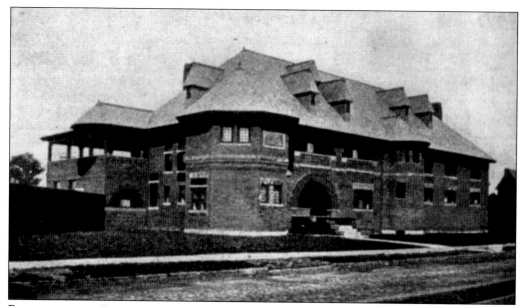

PROBABLY THE FIRST PHOTOGRAPH OF THE DAC CLUBHOUSE. This image was taken sometime between completion of the clubhouse in March of 1888 and October of 1889, when a gymnasium was added to the right end of the building. Construction of the clubhouse had proceeded at breakneck speed during the fall and winter of 1887 so that the first annual meeting in March of 1888 could be held in the new, unfurnished building. Note that a 10-foot wooden fence is in the photo but not in the architect's original drawing.

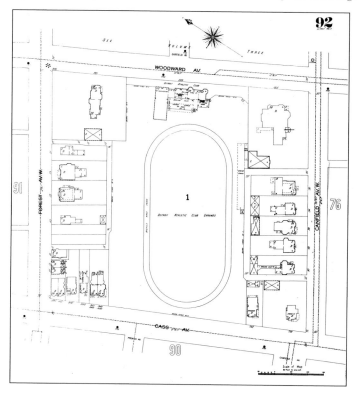

AN 1897 MAP OF THE COMPLETE DETROIT ATHLETIC CLUB'S FACILITIES. This map is from a commercial atlas of the City of Detroit, whose boundaries at that time were only a few blocks north of the DAC. Clearly shown are the fence surrounding the athletic fields; the very fast, but dangerous to any runner who fell, packed-cinder running track; and the start/finish field grandstands. Not shown in the diagram is the baseball field; home plate was located inside the turn nearest the clubhouse.

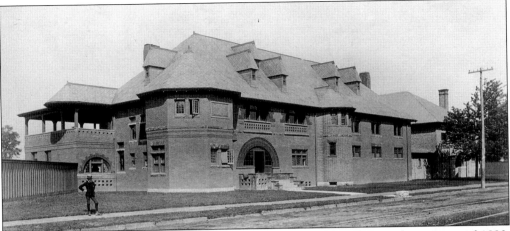

ENLARGED DAC CLUBHOUSE c. 1890. This photo, probably taken in the summer of 1890, shows the addition of the two-story gymnasium that was completed in October of 1889. Swelling club memberships necessitated the enlargement of the clubhouse just a year after its completion. Basketball, which would not be invented until the next year, was not a factor in the decision to build the addition, but it was there that the DAC teams dominated local teams until 1913.

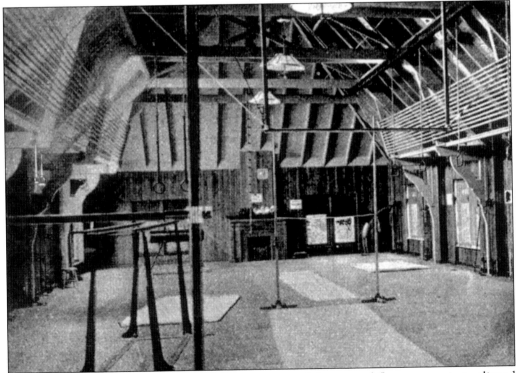

THE ORIGINAL DAC GYMNASIUM. This is a view of the second-floor gymnasium, aligned parallel to Woodward Avenue, looking north. Note the massive wooden supports holding the steam heating pipes to the base of the ceiling/roof structure. A fireplace in the north wall supplemented the steam heat. The open construction shows the roof's heavy framing and the complete lack of insulation. Shown also are a number of gymnastic training devices, indicators of club members' interests in 1889.

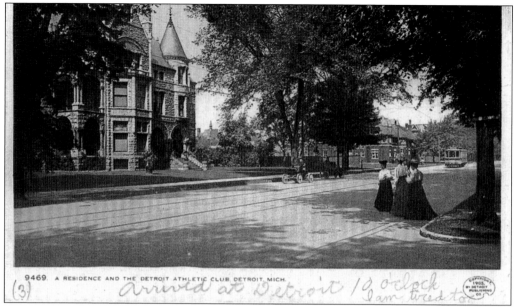

9469. A RESIDENCE AND THE DETROIT ATHLETIC CLUB. DETROIT. MICH.

(3) *arrived at Detroit 10 o'clock I am tired to*

WOODWARD AT CANFIELD IN 1906. This postcard depicts the DAC in its neighborhood setting. The David Whitney house, in the foreground, also shown in the map on page 12, is visually unchanged to this day and operates as one of Detroit's finest restaurants. The postcard was printed "colorized" from a black and white photograph. Pictured is a street car just passing the DAC going south on tree-lined Woodward Avenue.

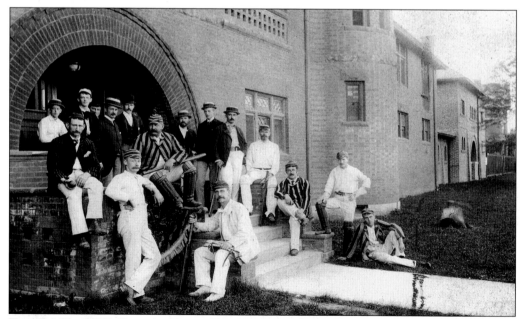

THE DAC'S 1889 CRICKET TEAM. Two DAC members, John C. Lodge, in the bowler hat standing in the back row, and George P. Codd, seated on the grass at the far right, were destined to become mayors of Detroit. Additionally, Lodge had an expressway named for him, and Codd had an athletic field named after him. The year this picture was taken, the DAC won a city baseball championship with a number of the men here pictured on that team.

14

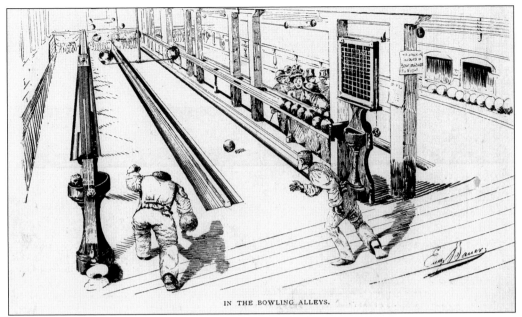

IN THE BOWLING ALLEYS.

THE DAC'S FIRST BOWLING ALLEYS. The new club's largest investment in sports equipment was undoubtedly its bowling facility. The six lanes were on the west side of the clubhouse and were below grade so to rest on a clay base. The illustration shows two lanes in play, observed by both men and women. Note the double-sided chalk score boards and the elevated ball return tracks. The difficult-to-read sign on the post says, "No snickers in the bowling alleys tonight."

ANOTHER LOOK AT THE CLUB'S CRICKET SQUAD. John Lodge's cricket team, in this photograph taken in front of the Woodward Avenue clubhouse, also includes a few youngsters, no doubt the sons of members of the Detroit Athletic Club. Some of the team wear leg and knee padding.

15

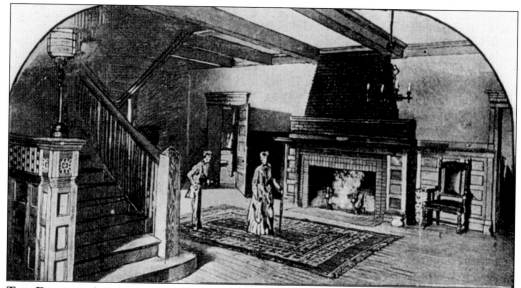

THE DETROIT ATHLETIC CLUB'S RECEPTION HALL, 1888. The elaborate lobby said to be finished in hardwoods was probably compatible with the style members were accustomed to in their homes. The room appears to have elaborately paneled wainscoting and a wooden floor. A large fireplace dominates one wall. A sign of the times is the presence of a spittoon strategically placed near the big chair. The staircase leads to the second-floor gymnasium.

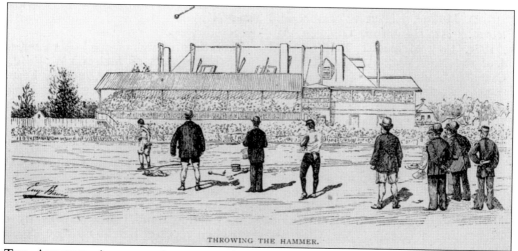

THROWING THE HAMMER.

THE AMATEUR ATHLETIC ASSOCIATION'S FIRST TRACK AND FIELD MEET, HOSTED BY THE DAC. Just months after the clubhouse was finished (on September 19 of 1888) the club conducted an impeccably managed major event. Even though DAC athletes failed to win many points, the club was widely praised in the press for the way the events were conducted. In the artist's depiction of the hammer throw can be seen the clubhouse before the additional gymnasium wing was added.

16

PRACTICING THE POLE VAULT ON THE DAC'S FIELD OF PLAY. Almost certainly, the athlete honing his skills is Theodore Luce. He began competing as hurdler, but when Fred Ducharme became virtually unbeatable in that event, he switched to the pole vault. Luce, a natural in that event and with Coach Murphy's tutelage and hard work, became a champion. His greatest moment came October 3, 1891, in the AAU National Championships held in St. Louis. It was near the end of a grueling season that had left many DAC athletes worn out or injured and the team doing poorly. The DAC needed at least one first-place finish to avoid athletic humiliation. Luce was up to the challenge and cleared the bar set at 10-feet, 6-inches, earning the only "first" of the meet. While the height of Luce's leap seems paltry by today's standards, the new Olympic Games record, established in 1896, was 10-feet 9-inches.

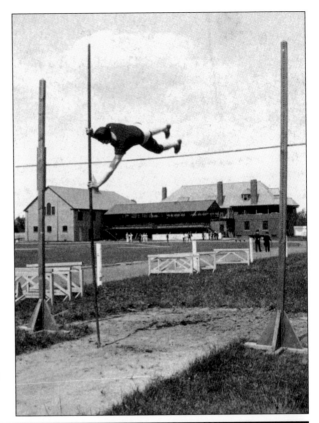

DAC BASEBALL IN SIMPLER TIMES. Note the absence of a batting helmet, gloves, catcher shin guards, or the black edging around home plate. The Detroit Athletic Club came into being with 17 members of an earlier Detroit baseball team that used the same name. In 1889, the DAC baseball team won the hotly contested Detroit Amateur Championship. On that team were future Detroit mayors, John C. Lodge and George P. Codd.

SOME THINGS DON'T CHANGE. The discussion with the umpire seems to have always been a part of the game. The uniforms indicate the picture was taken before 1900. At that time, before the American League Detroit Tigers, professional sports were held in very low regard. In fact, any participation with other compensated athletes would bar prospective Detroit Athletic Club candidates' membership. One DAC member was asked to resign after his association with a professional team became known.

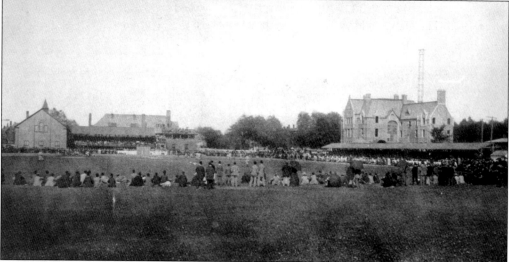

THE DAC VERSUS CORNELL UNIVERSITY IN BASEBALL, MEMORIAL DAY, 1892. Many of the sports with which we are familiar today were, in fact, in flux when this game was played. It would be the following year before the 60-feet 6-inches pitching distance would be officially established in baseball. Basketball team size was variable, and the new game of football had yet to throw a forward pass. The DAC's 1892 baseball team, following the winning of the Western Championship the previous year with a strong line-up of men who would become leaders in Detroit's business and political life, went on to win the National AAU Baseball Championship. The view in this photograph is from Cass Avenue looking east toward Woodward. An overflow crowd spilled onto the outfield grass. DAC member David Whitney's mansion is at the extreme right, the carriage house yet to be built. Barely visible, behind the Whitney, is one of Detroit's early 100-foot street light towers.

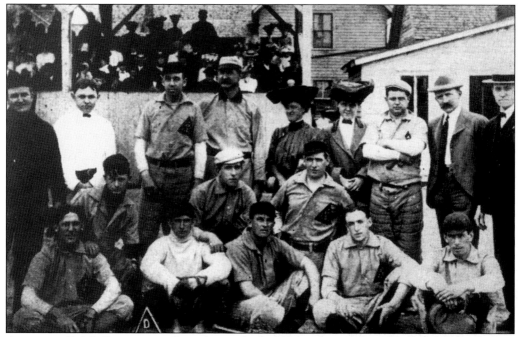

AMATEUR DAC BASEBALL. This photo, date unknown, was taken at the west end of the grandstands on the south side of the field. The ladies' hats would indicate a date sometime before 1900. The actual field was originally the location of the Peninsular Cricket Club, a site taken over contractually by the DAC while it was forming and before the clubhouse was built. While not fashion plates, early DAC teams established many winning seasons.

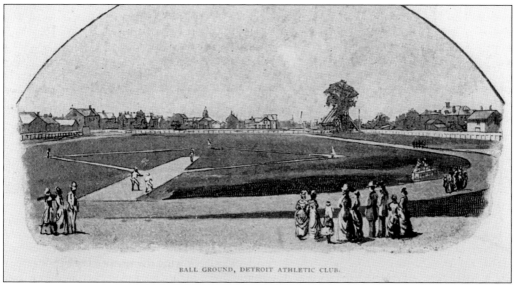

BALL GROUND, DETROIT ATHLETIC CLUB.

AN ARTIST'S VIEW OF THE CLUB'S BASEBALL DIAMOND. This illustration, probably drawn in the second floor grandstand, looks west toward Cass Avenue. Beyond the fence to the left is Canfield Street and to the right is Forest Avenue. Home plate is inside the first turn of the cinder running track. In the extreme right corner of the fences is a summer storage area for an artificial toboggan slide that was briefly used in the very early days of the DAC.

19

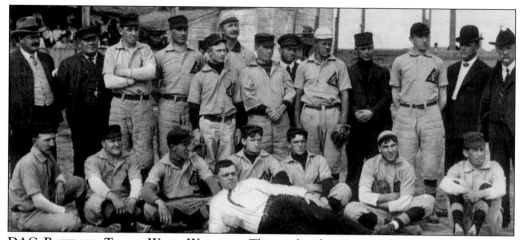

DAC Baseball Teams Were Winners. This undated team picture portrays the type of men who produced championships for the Detroit Athletic Club. Baseball was all the rage in Detroit in the late 1880s and was one of a few team sports available to young men. Basketball had yet to be invented, football was in its infancy, and cricket, with its elaborate equipment and interminable length of play, was beyond the reach of many. The city by then, with a population under 285,000, was a beehive of competing teams. In that hotly contested environment, the DAC won the Detroit City Championship in 1889. In 1890, the club won the city, state, the Amateur Athletic Association Western Championship, and the AAU National Championship played at the Polo Grounds in New York City. In 1891 and 1892, the DAC again won the Western Championship and in 1892 repeated with the national championship.

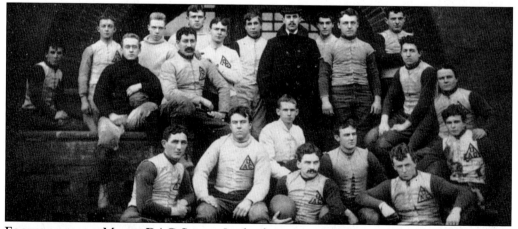

Football Was a Major DAC Sport. In the first year of its existence, the Detroit Athletic Club Board of Directors authorized 23-year-old member Sidney Trowbridge Miller to organize a football team. In that same year, he was admitted to the practice of law. He had played football at Trinity College in Hartford, Connecticut. But few of the 18 men he recruited had played the game or knew the rules, so he spent the first year teaching the fundamentals of the game. The team's dedication to the program was such that they showed up for practice every afternoon in the fall of 1887. Finally, feeling ready to play, the untested DAC team challenged the University of Michigan to a game that was played November 17, 1888. The outcome was predictable, but not a disaster; the DAC lost 14 to 6. It was the club's best showing against Michigan. In the four years between 1890 and 1895, when the teams played each other, the DAC lost all four in the process amassing zero points to Michigan's 92.

AFTER A FULL SEASON OF PRACTICE THE DAC'S TEAM WAS READY TO PLAY. The club began its first season of real competition with a November 17, 1888, meeting against the University of Michigan. Michigan won 14 to 6, the DAC giving strong competition. Later that year, the DAC beat Albion College 18 to 0 and started a series that ran for years. In 1889, the DAC established a tradition by playing a Thanksgiving Day game, beating a Pittsburgh alumni team.

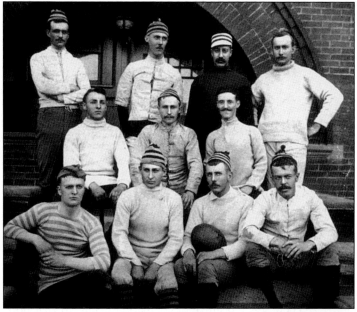

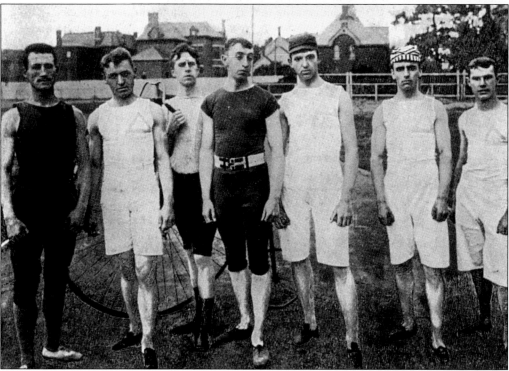

THE DAC PROVIDED ATHLETES WITH A WIDE RANGE OF OPPORTUNITIES. In spite of strong prohibitions against contact with "professional" athletes, the DAC did provide its athletes with an "expert trainer." This 1888 picture shows John Collins, at the far left, who was a self-taught athlete. Collins came to the DAC after five or so years at the Detroit YMCA. Collins' specialties were in boxing and fencing, but he was apparently able to help hurdler Fred Ducharme, shown in the middle of the photograph.

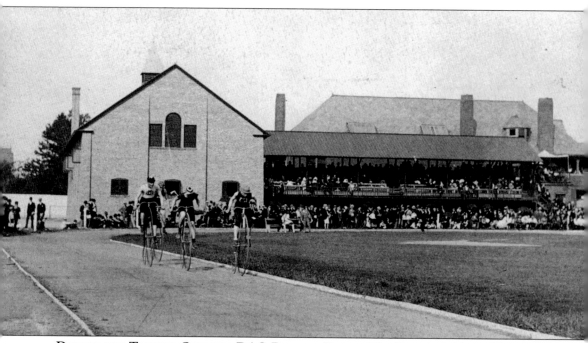

DETROITERS TURNED OUT FOR DAC BICYCLE RACES. The Detroit Athletic Club was five years old when this 1893 bicycle race was staged. Although expensive and dangerous to ride, the high-wheeler bicycles were the vehicles of choice for racers of the day. These bicycles and the later, smaller-wheel, chain-driven "safety bicycles," were extremely popular, not only for sport but for personal transportation. In their way, they contributed to the rapid development of automobiles by demanding good roads on which to ride. And, in fact, bicycle manufacturers created many of the early automobiles. The sport of bicycle racing diminished in the United States as cars became ever more available, but still thrives in Europe, particularly in France. Clearly seen in this photo are the 16-foot wide running track, the 1889 gymnasium addition, and the first-base area of the baseball diamond.

Two

THE NEW DETROIT ATHLETIC CLUB

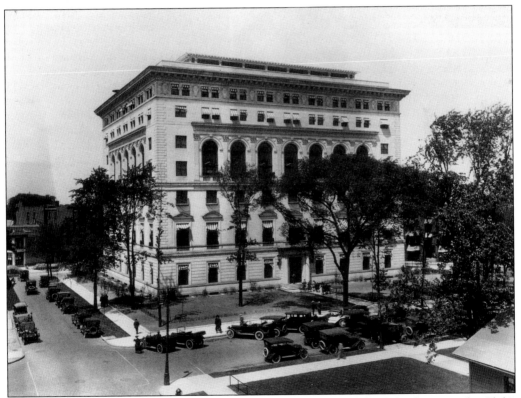

A GREAT DAY IN DETROIT. On a spring day in April of 1915, with fresh landscaping, the Club's new home has its first portrait taken. The beautiful lawn later had to be sacrificed to permit widening of a fire department route and the expansion of Madison Avenue. Besides the many open-bodied automobiles arrayed in front and along the side of the Club, barely visible in the bottom left is a horse and buggy stand, which was located along the street named John R.

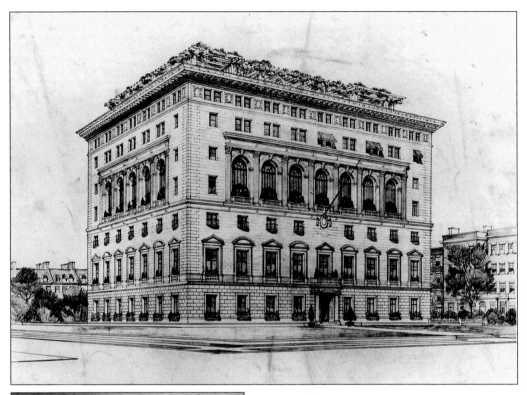

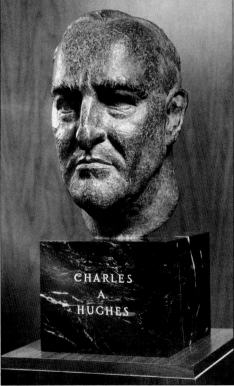

A PALATIAL LANDMARK. This is an original artist's concept of what the DAC's new clubhouse was to look like. Designed by architect Albert Kahn, the structure even called for a garden pergola on the rooftop. That pergola was never built nor were sleeping rooms, but the roof did see the construction of two squash courts. Kahn's stated goal for the structure was for it to remind people of early Renaissance palaces. (Image courtesy of Albert Kahn Associates.)

THE DRIVING FORCE. Truly the driving force behind the creation and development of the new Detroit Athletic Club was Charles A. Hughes. "Mr. DAC," a charter member and both the Club secretary and executive head for many years, he also founded and ran the Club's fine magazine, the *DAC News*. The Michigan native was also instrumental in organizing the syndicate that created Detroit's first professional hockey team, the Cougars (they eventually became the Red Wings). This sculpture was an anonymous gift to the Club.

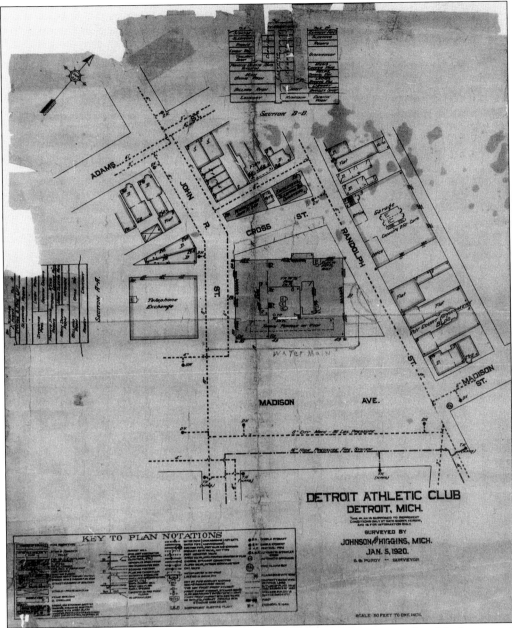

An Updated Site. This engineering survey map of the DAC was completed in January of 1920 by S.G. Purdy and outlines some of the neighborhood where the Club's new home was located. The newly widened expanse of Madison Avenue is immediately apparent. To the right of the clubhouse in the center is a parking garage for 250 cars as well as the Roy Court apartment building, both later demolished by the Club. Just north of the facility, across Cross Street, are both employee sleeping quarters and a warehouse for the DAC. Also noticeable at the top and left side are cutaways of the building's interior showing the basic clubhouse layout. One can also see the frame pergola still outlined on the rooftop. It should also be mentioned that the Home Telephone Exchange Building at left predates the DAC.

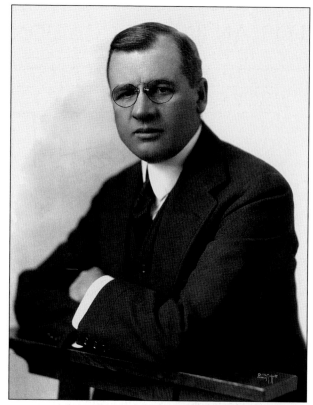

HE SERVED AS THE DAC'S FIRST PRESIDENT. The new DAC became a definite entity on January 4, 1913, when 109 men met at the Pontchartrain bar in Detroit. Hugh Chalmers was made chairman of the meeting and led the organization of the new DAC with the specific purpose to find land for and build a new clubhouse. Chalmers, president of Chalmers Motor Company and co-owner of Saxon Motor Company, became the Club's first president, serving from 1913–1916.

THE CLUB EMBLEM. Designed to carry over the traditions of the original club (with it's fraternal symbolism), the new DAC emblem retained the Greek delta inside a triple-ringed square with the letters DAC. This is the final emblem in a long evolution of designs (note the various logos in the next chapter). The first approved Club emblem—a hand-drawn triangle with the letters DAC inside—can be found in the minutes of a Board meeting from June of 1889.

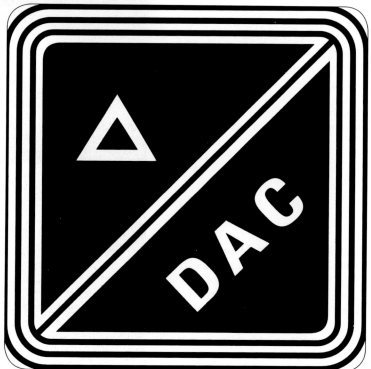

CAN'T BEAT THIS FOR AN IDEAL LOCATION

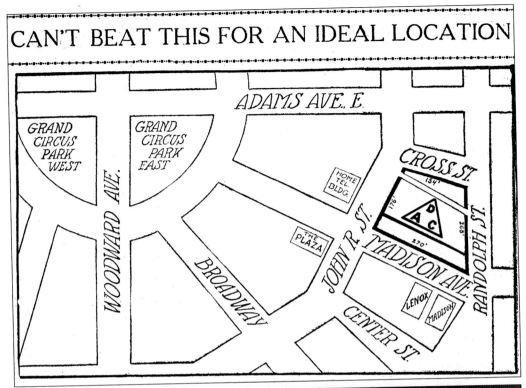

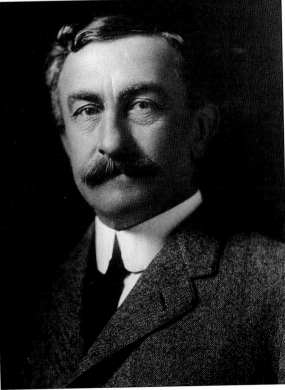

CAN'T BEAT THIS FOR AN IDEAL LOCATION. That was the headline above this Detroit Free Press map of the new DAC published in January of 1913, just days after the Club came into being. The new clubhouse, having moved closer to the heart of downtown Detroit from its north Woodward location, was wonderfully situated just off of Grand Circus Park.

HIS NAME IS FIRST. Henry B. Joy, a stalwart member of the original DAC and a fine athlete, was one of the Club's founding members. In fact, his name is listed as member number one on the rolls of the new DAC. Joy was at the time president of the Packard Motor Company and would serve as DAC president in 1919.

27

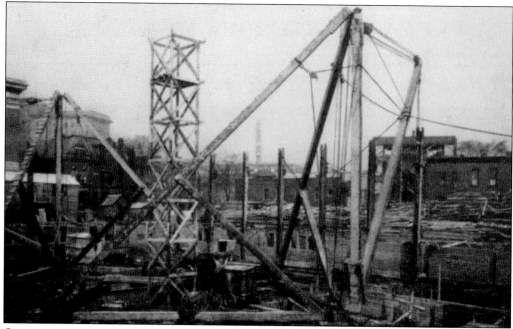

CONSTRUCTION GETS UNDERWAY. Following a "stormy" Board session, the construction contract to build the new clubhouse was awarded to the Vinton Company in January of 1914. Vinton was a Detroit firm. Construction then leapt forward with the goal—never met—of completion by Christmas of 1914. In this photo, we can see the foundation and beginning of structural steel being put in place in April of 1914.

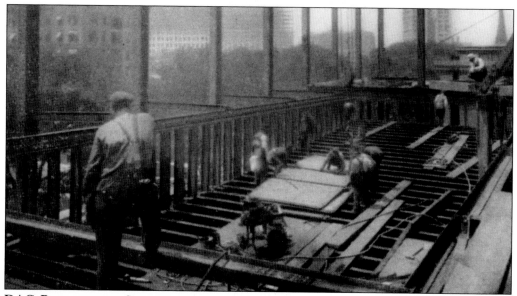

DAC RISES TO THE SKYLINE. Construction on the new clubhouse continued at a furious pace, and by July of 1914, the steel frame of the entire building was taking shape. Here work is being done on the tank to hold the dramatic fourth-floor pool (note the tightly paced steel floor beams designed to support the tank). In the distant background one can see several other mammoth skyscrapers going up, including the Statler Hotel.

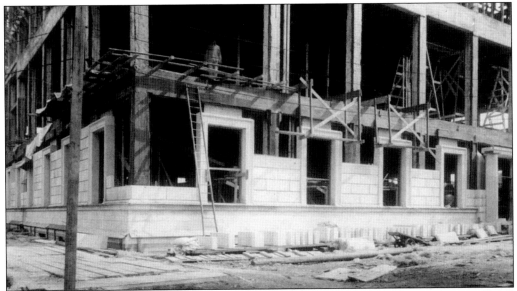

THEN CAME THE WALLS. Besides the steel (which came from a Pittsburgh firm that met DAC representatives on a trip to look over other club designs), the outside walls were beautifully appointed with Bedford limestone, here being applied in August of 1914. This perspective is taken from the corner of John R. and Madison Avenues. A worker can be seen posing for the photo. Blocks of cut limestone litter the ground in front of the building.

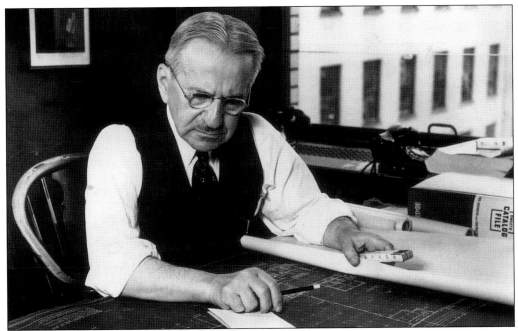

AN ARCHITECTURAL GENIUS. Albert Kahn, who was known as the architect to the auto industry, designed the clubhouse based on an Italian palace from the Renaissance period. His selection as architect was no surprise—he had built huge auto factories for Chalmers, Packard, Ford, Dodge, and Hudson companies. His beautifully designed building featured great exterior and interior touches and called for only the finest materials. (Photo courtesy of Albert Kahn Associates.)

29

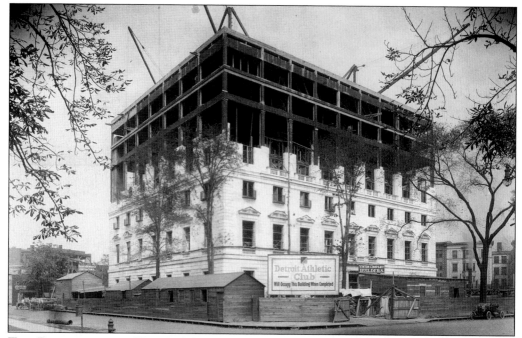

THE BEAUTY OF THE NEW DAC BEGINS TO SHOW. The DAC rises from the ground in October of 1914. The large sign in front tells the world that the "Detroit Athletic Club will occupy this building when completed." Limestone now reaches past the fourth floor. Besides all of the wood construction "huts," note at far right a steam engine belching smoke, and at far left, a horse-drawn wagon.

DETROIT'S NEWEST LANDMARK. This rare photo from early 1915 shows the outside of the new clubhouse completed, although a platform on the roof clearly implies additional activity. Most of the construction equipment and wood buildings have been removed, and work is continuing on the inside to make the facility ready for its April 1915 opening.

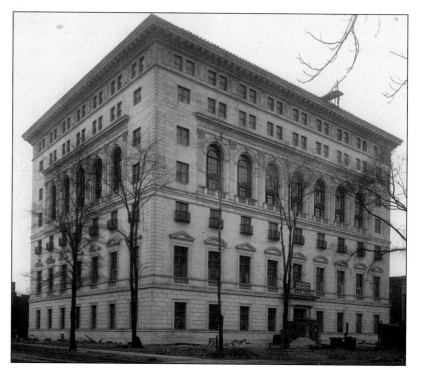

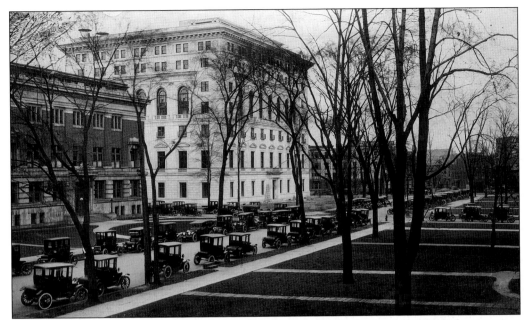

A GLORIOUS DAY FOR DETROIT. A few days before the Club opening in 1915, a preview was held for the ladies on April 16, 1915. The occasion was featured by an aquatic exhibition by Annette Kellerman. Note the wide lawns before Madison Avenue was made into a divided thoroughfare. Of all the cars parked around the clubhouse that day, only 15 were gas automobiles (the rest were electric).

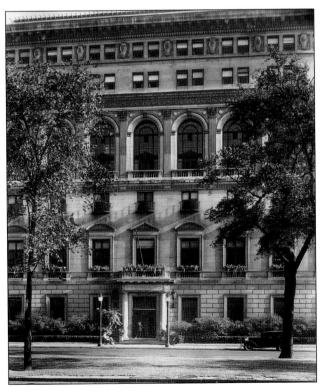

THE GRAND ENTRANCE WAY. This photo was taken a few years after the Club opened (note that Madison is now a boulevard) but beautifully illustrates the limestone façade of the new clubhouse with its fine windows and limestone carvings. Behind the large windows, four floors up, is the lap pool. Albert Kahn wrote that the arrangements of doors and windows were the "most important" aspect to the façade.

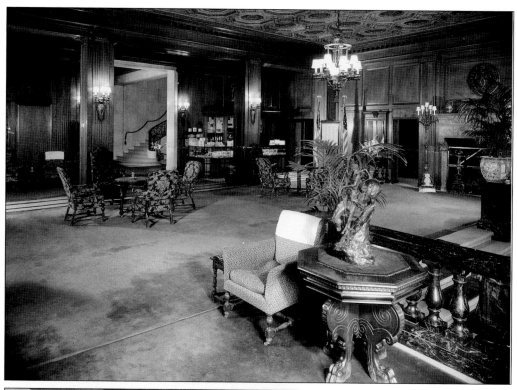

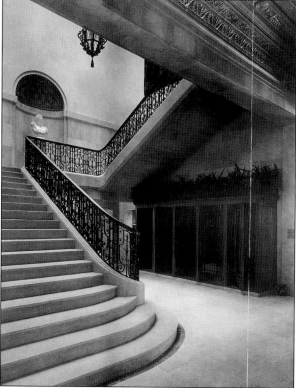

THE STUNNING MAIN LOBBY.
The DAC lobby features a
dramatic ceiling and oak paneled
walls. The fireplace at right and
many of the items seen here (like
the Remington sculpture in the
foreground and the emblem over
the fireplace) can still be seen in
the Club. Along the back wall is a
cigar counter that was later moved
to a new location. Behind the
two flags is a roster board—listing
members in the service during
World War I.

THE GRAND STAIRCASE IN 1915.
The stairs to the Main Dining
Room were a wonder of marble
and limestone featuring a Yellin
railing. One can also see part of
the ceiling treatment, and note
the old fashioned phone booths.
The bust of Hermes on the first
landing would later be replaced by a
commissioned artwork dedicated to
World War I veterans.

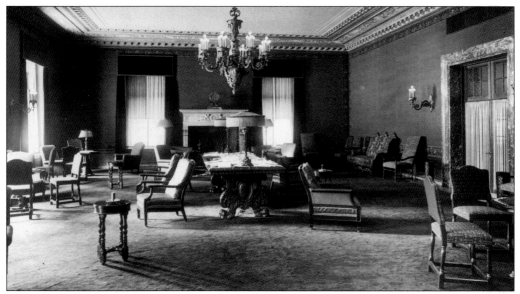

THE READING ROOM IN 1915. The Reading Room was a quiet place on the first floor of the new clubhouse. Within a short time it became home to many of the Club's finest pieces of art. Another beautiful fireplace—with the DAC logo embedded—is on the far wall, and Caldwell lamps (and chandelier) can be seen. The clock on the mantel was a gift to the Club from C.H. Wills, an early Ford chief engineer.

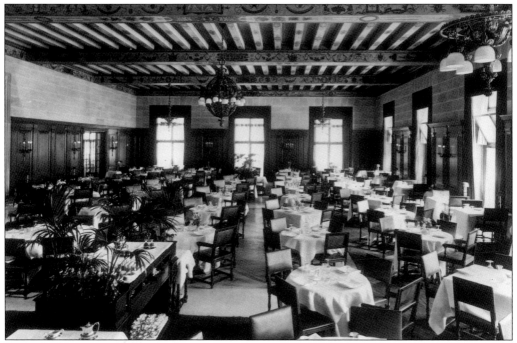

INSIDE THE MAIN DINING ROOM. The center of Club activity, this photo of the Main Dining Room probably dates to shortly after the DAC clubhouse opened. The beautifully crafted ceiling with its lavish murals of Greek athletes and garden themes dominates the room, along with the chandeliers. Over the years, this room has seen thousands of functions of all sizes and types.

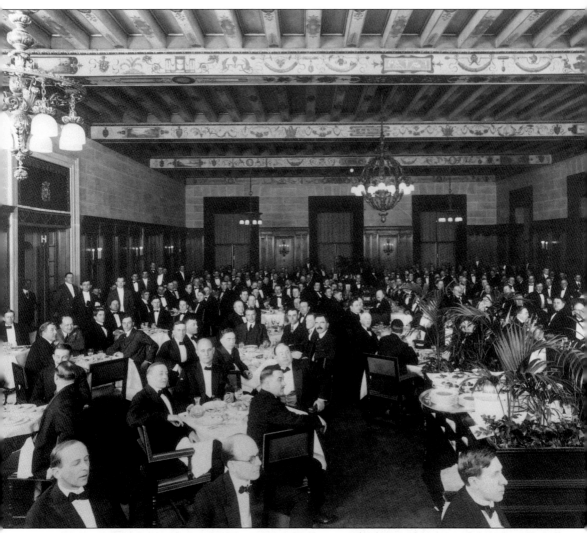

AN EARLY GATHERING IN THE MAIN DINING ROOM. The beamed ceiling of the Main Dining Room again dominates this photo of an early black tie affair at the Detroit Athletic Club. A. Duncan Carse of England designed the ceiling. Nothing was duplicated; each mural differs from the other with a marvelous skill shown in the many designs of leaves, fruit, parrots, other birds, monkeys, and other animals. Every so often a panel representing athletic games is illustrated, making every part of the ceiling interesting. The painstakingly frescoed ceiling beams were later painted over (and then restored again to grandeur just a few years ago). Daringly, Albert Kahn located the Main Dining Room and banquet rooms below the swimming pool on the fourth floor. Those stone blocks that make up the walls were no simple "cinder blocks," but finely cut limestone pieces. They too have been hidden over the years.

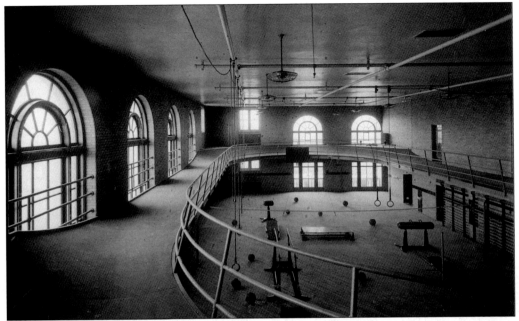

THE DAC GYMNASIUM IN 1915. Of particular interest are the windows, which mirrored those on the swimming pool side of the building. They were later blocked off and the entire gym paneled over. A cork running track was suspended above the gym until part of it was removed so that a stage could be built into the far wall and balcony seating offered. Note the gymnastic equipment displayed.

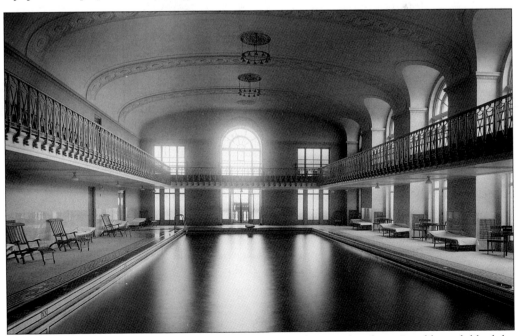

THE SWIMMING POOL IN 1915. The DAC pool, known first as "the plunge" and later dubbed the Natatorium, can be seen in all its glory. The deck above the pool was originally meant for viewing but later became the running track. A diving board can just be seen under the arched window.

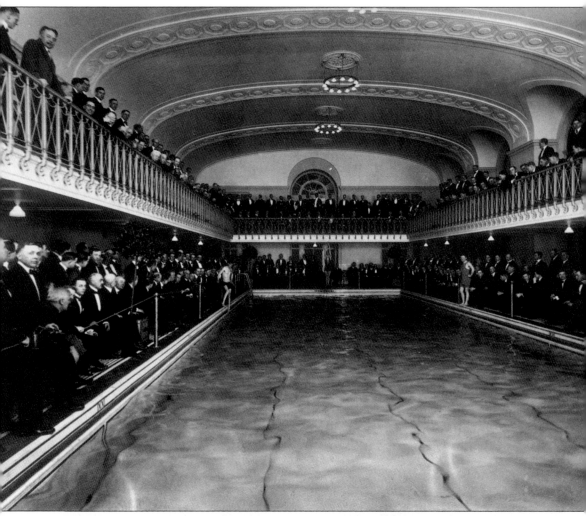

THE NATATORIUM SHINES. When the new Detroit Athletic Club opened in April of 1915, the swimming pool was a center of attention. The beautifully crafted ceiling over the 25-yard lap pool and its large windows gave the natatorium an almost outdoor feeling, especially when the sun poured in through those beautifully arched windows. It is believed that this photo was taken during a swimming and diving exhibition that drew 500 members during the grand opening of the new clubhouse. Over the years the pool has seen many swim meets and competitions. It was the scene of one of Johnny Weissmuller's indoor swim records in the 1920s. Luncheon meetings have been held around the pool and lavish parties over the pool (Albert Kahn designed a special floor for such uses). Today the natatorium is home to swim lessons, various events (like the Father & Son Party), and a fun little game known as "basketbrawl."

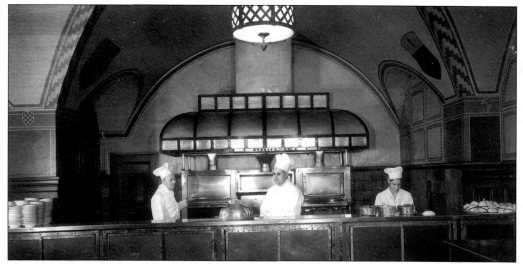

WHAT MADE IT IN THE GRILL ROOM. This is the main grill in the DAC Grill a few years after the Club had opened. The fanciful designs on the hood of the grill have been covered up, but one can still see parts of the ceiling treatments and even the designs embedded into the Pewabic tiles.

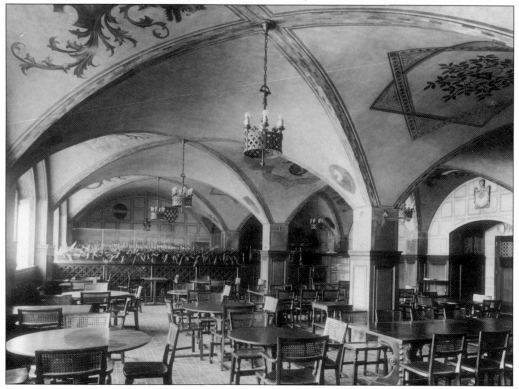

THE GRILL ROOM IN 1915. The wonderfully vaulted ceiling of the Grill Room, the DAC's world-class restaurant, is apparent in this image. The floor is of renowned Pewabic tile, and the ceiling stencils were crafted by A. Duncan Carse, who created the Main Dining Room. The Grill is patterned after rooms in the 14th century Palazzo Vincigliata, a well-known castle outside of Florence, Italy.

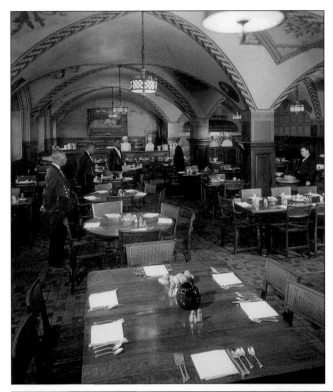

ANOTHER VIEW OF THE GRILL ROOM. This is another look inside Kahn's wonderfully designed Grill Room. Besides the grill along the back wall (to the far right), note the rest of the serving area under the painting known as the "Reclining Nude" by Rolshoven. DAC staff are at the ready to serve members coming for lunch or dinner.

SHOWCASE OF THE EARLY YEARS. This room on the second floor was originally called the Palm Room and is now the Pontchartrain Room. The working fountain in the center of the room did not last there long; palms and potted plants were in lavish use in those days. Note also the delicately carved ceiling with its cameo-like inlays.

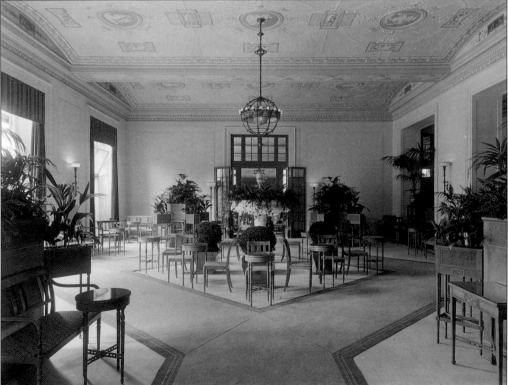

LADIES ONLY ENTRANCE. For many years, ladies entering the DAC had their own entrance (they were not allowed in large sections of the clubhouse). This photo is of DAC doorman Jim West helping two ladies on their way into the Club in 1921. That's a 1921 Packard.

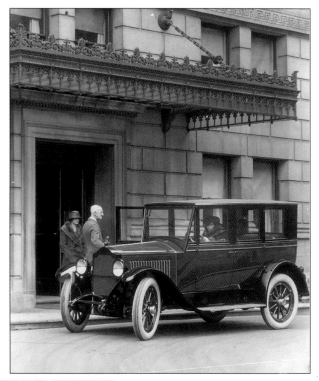

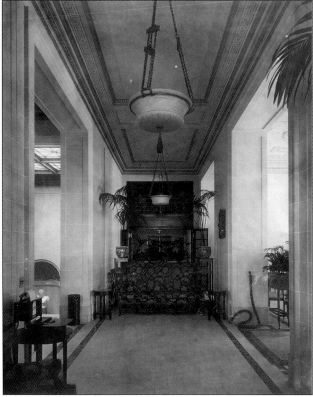

THE GRAND HALLWAY. This is the second-floor hallway outside of the Palm Room in 1915. Note the "ticker tape" device to the left. There were several of these devices in the Club so members could be sent information, say about the late arrival of a business associate. Beyond the couch and potted plants is the ladies-only section of the clubhouse.

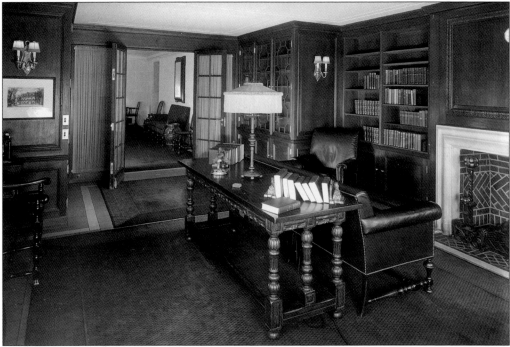

THE DAC LIBRARY IN 1920. Also found on the second floor of the new clubhouse, just off the grand staircase, was a small, but well stocked library, a quiet place where members could lounge or read. It has remained virtually untouched since the building first opened.

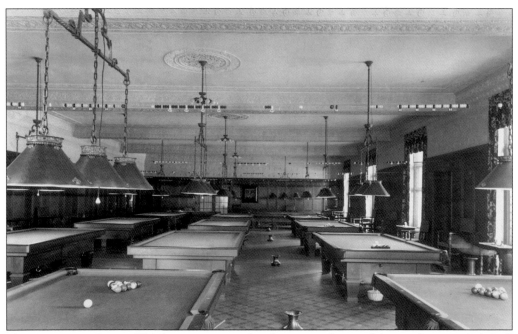

THE BILLIARDS ROOM. This large room is today the carpeted area of the newly expanded Grill Room. But when the Club first opened, the game of billiards was a highly popular pastime for members. Note the spittoons in the middle of the floor between each of the tables.

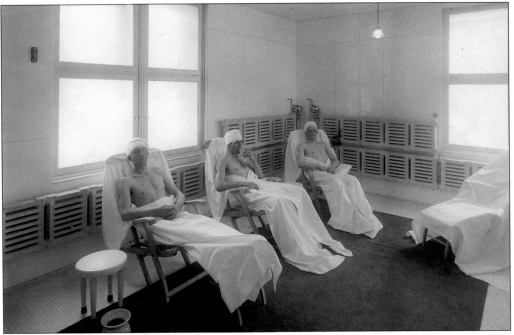

ALWAYS A PLACE FOR RELAXATION. This is the DAC "bath department," as it was called shortly after the building opened in 1915. These toweled and wrapped members are relaxing in what appears to be an early version of the Club's steam room.

THE DAC BATH DEPARTMENT. This is another photograph of the Detroit Athletic Club's "bath department" from 1915. The member at the far left is being "cooked" in what appears to be an old-fashioned steam cabinet. Also note the tiny sink and faucet and the robed gentlemen in the background.

41

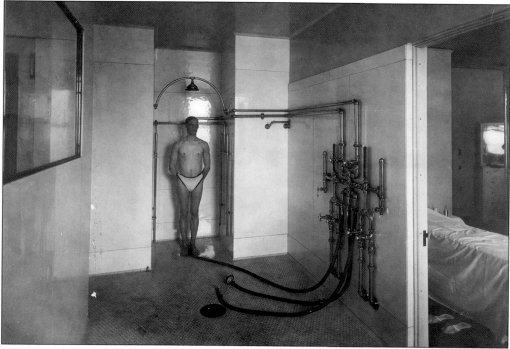

AN EARLY SHOWER FACILITY. This unique image from the clubhouse in 1915 shows a member testing out what is clearly a very complicated (and very early) shower with enough hoses, gauges, and dials to confuse any novice. Besides the fairly normal showerhead over the man, there are three choices of hoses to choose from, for additional cleaning (what the differences are, we do not know). To the right is a massage table.

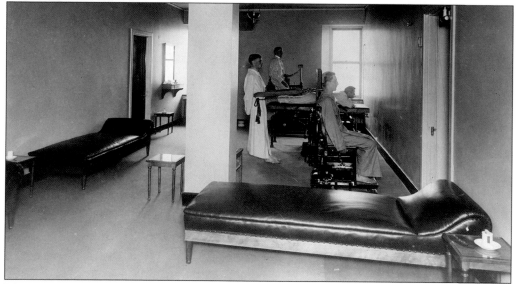

MORE EARLY ATHLETIC EQUIPMENT. This is another early image inside the DAC's health and fitness center. It shows several members stretching and working out on equipment that is clearly not standard issue any more. The man nearest to the wall is seated on a saddle horse device of some kind. (Photo courtesy of Albert Kahn Associates.)

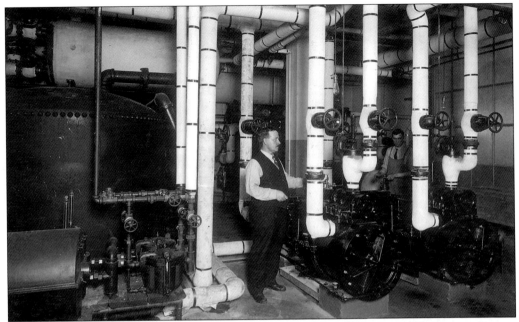

DAC Furnace Room in 1915. This is a rare view of the clubhouse sub-basement furnace room, with the DAC's unnamed chief engineer checking out the hot steam popes for sending heat through the building. The engineer (and his assistant in the background) is formally dressed with vest and tie despite the hands-on nature of his job.

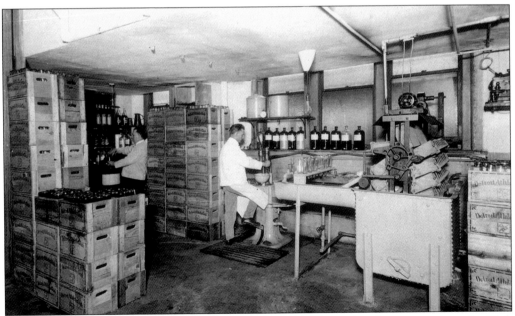

Made by the Detroit Athletic Club. This is the DAC's own bottling room, where the Club made and bottled soda, sarsaparilla, ginger ale, and other non-alcoholic beverages during the Prohibition years. Note the cases stacked high stamped with the Club logo. Over the years the Club has made various culinary products for members to purchase (and, in the early years, have delivered). These have included things like "cakes, pastries, cold hams, ices, and other articles."

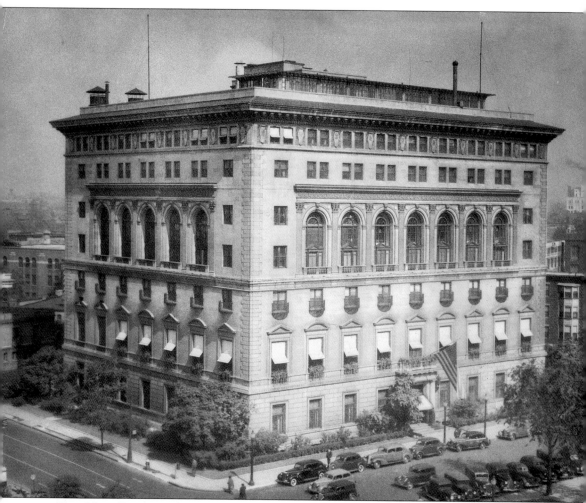

THE NEW DETROIT ATHLETIC CLUB. This photograph was taken in the late 1930s, some 20 years after the new clubhouse had opened for members along Madison Avenue. Despite the Depression that continued to weigh heavily on the City of Detroit, the DAC was able to survive and even thrive as a home to the city's industrial leaders. The Club managed to survive by cutting dues, but still at one point about 1,000 members left in the span of one year, a decrease of 30 percent of the membership. All through the painful 1930s, the DAC refused to let its services or clubhouse deteriorate. Then, by 1936, the membership was nearly full again, and the Club ended the year without a loss (the first time since 1929). Clearly better days were ahead for one of Detroit's enduring organizations.

Three

ATHLETICS AT THE DAC

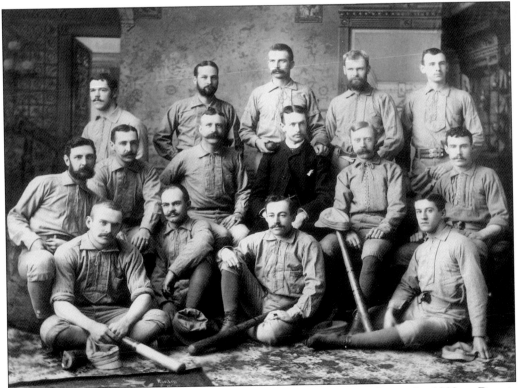

BASEBALL WAS THE FOUNDATION OF THE DETROIT ATHLETIC CLUB. In 1883, a Detroit amateur baseball team calling itself the Detroit Athletic Club had established itself as a quality local competitor. In 1887, when the DAC, as it is known today, was formed, 10 of the 26 original "new" Detroit Athletic Club members came from that baseball team. As can be seen, the "old" DAC team uniforms carried no team name or logo.

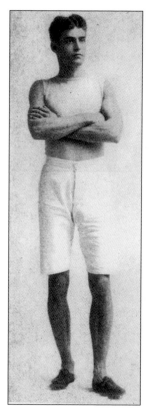

HARRY M. JEWETT, SUPER ATHLETE, BUSINESSMAN, AND PRESIDENT OF THE DETROIT ATHLETIC CLUB. Harry Jewett's impact on the DAC began in 1890, with a victory in the 100-yard dash during that year's AAU Western Championship games. During the next five years he dominated track meets, winning dozens of medals. In 1892, the DAC awarded him a life membership. He later organized and presided over the Paige-Detroit Auto Co. and later Jewett Car Company. In 1924, he was elected to the presidency of the DAC.

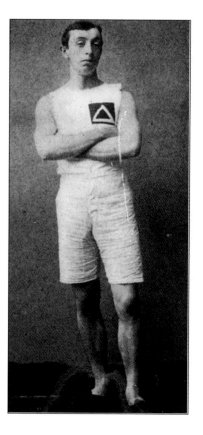

DAC CHARTER MEMBER FRED DUCHARME WAS WORLD-RECORD HURDLER IN 1890. One of three brothers who were among the founding members of the DAC, Fred was the star of the 120 and 220-yard hurdle events. In 1890, he became the National AAU Champion hurdler. While most successful in the hurdles, he competed in a wide range of events and in 1888 was awarded the "All Round Club Championship" by winning more points than all DAC members combined.

SPEEDSTER JOHN OWEN WAS SLIGHTLY BUILT BUT FLEET OF FOOT. At 5-feet 7-inches and 128-pounds, John Owen was small sized even by 1800s standards. In spite of beginning competitive running at age 28, in a time when life expectancy for males was 42.5 years, he set a record 9.8 seconds for the 100-yard dash at the AAU National Championships in Washington, D.C., October 11, 1890. In total, he won one broad jump and 37 dash events.

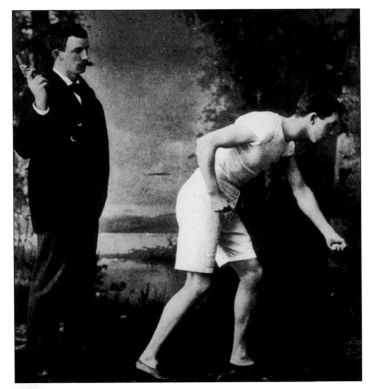

THWARTED IN HURDLE STARDOM, THEODORE LUCE WAS ABLE TO LEAP TO FAME. Ted Luce began competing as a hurdler but, faced with Ducharme's prowess in that event, switched to the pole vault. Luce seemed to have a natural ability in the event. It is probably Luce shown practicing in the page 17 photo. Luce's greatest moment came in the 1891 AAU National Championships when his first-place leap earned the DAC's only first-place finish, saving the team from athletic humiliation.

YALE'S MICHAEL C. MURPHY FINE TUNED THE DAC'S ATHLETES. The DAC, while brilliantly managing its first major track and field event, did poorly in the competitions, scoring just two out of a possible 161 points. To remedy that failing, Murphy, a known developer of Yale University track teams, was recruited by the DAC. He drove the DAC athletes with a whirlwind schedule of events that bordered on full-time jobs. Thereafter, the DAC was a respected power in amateur track and field events.

THE FOUNDING MAGNET OF THE DAC, FRANK W. EDDY. Eddy, pictured at right, the son of a prominent minister and a businessman/athlete, was a zealot for amateur athletics. Eddy was the force that organized Detroit's various athletic activities into the Detroit Athletic Club. On April 5, 1887, under Eddy's leadership, 29 of Detroit's prominent young men appeared before a Wayne County Notary Public to present their "Articles of Association," thereby formally launching the DAC. Six months later, 300 members had joined the new club.

John Kelsey, the Strong Heart That Pumped Blood into the DAC. Kelsey, age 24, in the lumber business, joined the DAC in 1890 to play baseball on a first-class team. He could pitch, field, and hit with power. Kelsey made the team in 1892. The team won the AAU Western Championship the year he joined it and then had to face the Eastern YMCA Champion team for the national title. The series began on October 10, 1892, with a 10-inning 7–7 tie. The DAC team went on to win the next three games, giving Detroit the national amateur baseball title. As the 19th century was ending, the DAC fell on hard times, but Kelsey kept the organization going through his financial support and serving a multi-year stint as president. In 1907, Kelsey formed a wheel company that supplied Henry Ford's Model-T production. By 1913, volume reached 13 million wheels. Kelsey personally supported the original DAC until it was reformed in 1913. He then served on the new Board of Directors for eight years and as a two-term Club president.

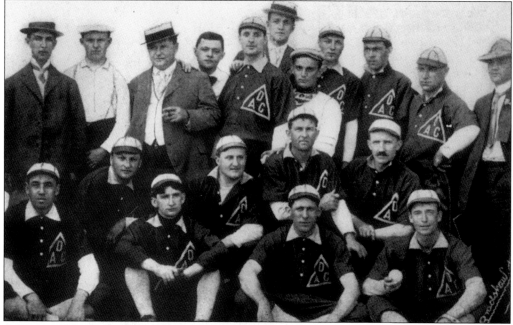

AMATEUR BASEBALL WAS A SERIOUS MATTER FOR THE DAC TEAMS. Baseball, the national pastime, grew out of the unprecedented gathering of young men for the Civil War. Camp life was boring, and spontaneous baseball games, requiring very little equipment, filled the void. After the war, returning veterans brought the joy of the game with them, cementing its place in nearly every city and town. The unnamed DAC men shown here took their responsibility to the game and their club very seriously.

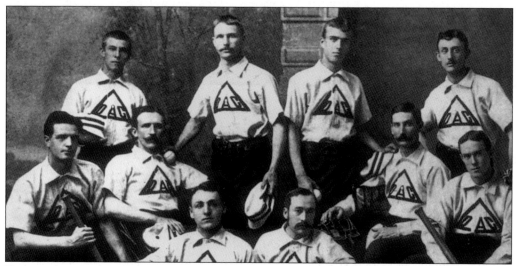

DETROIT'S 1889 AMATEUR BASEBALL CHAMPIONS. Unimaginable today was the intensity of competition that existed in a city filled with teams passionate about winning. Among the 1889 DAC champions were future mayors, pitcher George P. Codd (with a ball in his hand), top row, second from the right, and first baseman John C. Lodge, middle row, second from the left. It is interesting that Detroit's championship team had only 10 members, a lack of depth unthinkable today.

Hal West a Member of the 1892 Championship Baseball Team, Typical of the DAC Players. Hal West was a very good player who competed for the joy of playing. He never used the DAC games as a stepping stone to the professional level. Being on the DAC's 1892 amateur team was, in reality, a considerable financial burden for him and his teammates, with the need to devote valuable time to practice, play, and travel for the love of the game.

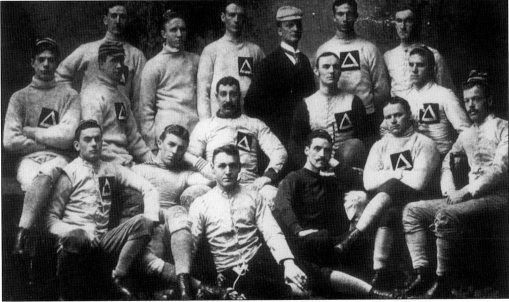

The DAC's 1891 Football Team Was Well-Rounded. In the top row at the extreme left and right are Fred and Henry Joy, who carry a patrician family name. Henry brought Packard Motor Car Co. to Detroit. Of equal stature is Russell A. Alger (middle row, far left), who was an investor in the Packard and Wright Airplane Companies. Seated second from the right is J.V. Gearing, the architect who designed the DAC clubhouse. Most of the football team members played other sports.

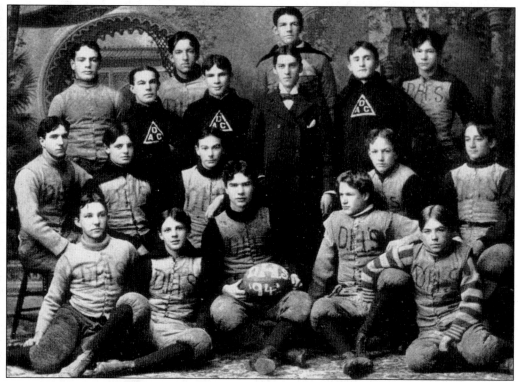

THE RULES WERE LOOSER IN 1894. This picture of the Detroit High School football team demonstrates the flexibility in selecting players in that time. One of the players was a U. of M. graduate who had played on the varsity team there and was the coach of the high school team. Three of the athletes shown are wearing Detroit Athletic Club sweaters, indicating that they played for the DAC while participating in high school football.

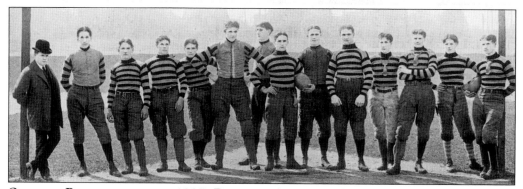

ON THE ROAD WITH THE 1897 DETROIT ATHLETIC CLUB'S FOOTBALL TEAM, ON THANKSGIVING DAY, THE MORNING OF NOVEMBER 25, 1897, IN INDIANAPOLIS, INDIANA. The team probably arrived the night before via train from Detroit and went on to beat the Indianapolis Athletic Club by an unknown score. About 90 days later, the Spanish-American War began with many DAC members participating. They came back different men with competitive sports less important in their lives, and the original DAC began to decline.

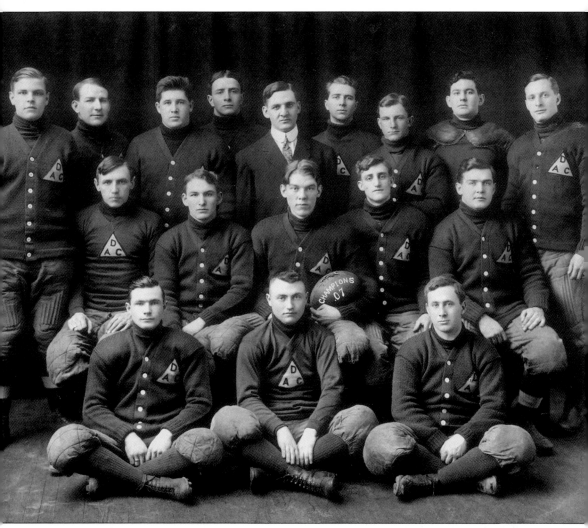

THE DETROIT CITY CHAMPION DETROIT ATHLETIC CLUB FOOTBALL TEAM. By that year, football contests between the DAC and college teams were over. There were, however, strong Detroit teams of various alumni organized into a quasi-league. The DAC team was the best of the best in the city. The year 1907 was a pivotal year. Just a few blocks north of the DAC, on Piquette Street, Henry Ford, a DAC member, was developing the Model-T auto that would forever change the city, the nation, and the Detroit Athletic Club. Already producing cars in Detroit, under DAC members' control, were Packard, Cadillac, Chalmers, Detroit Electric, Maxwell, and Oakland. Since the DAC was founded, the city had doubled in population. Many DAC members had been to the Spanish-American War and came back changed men. The city was changing, too; soon the torrent of cars produced by Ford would swing the entire economy of the city onto a path of boomtown growth. For better or worse, Detroit was becoming the motor capital.

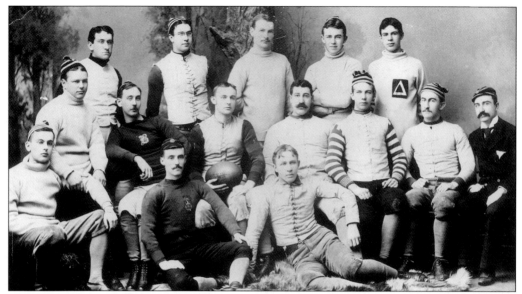

SUBSTITUTES WERE FEW FOR THE 1889 DAC FOOTBALL TEAM. The 14 players shown here were the total team that faced Albion College in 1889. The DAC began a seven-game football schedule with Albion in 1888, winning the first game 18 to 0. When the series ended in 1902, the DAC had won five of the games. It is remarkable, despite playing without pads, helmets, or facemasks, that injuries during the game did not demand more than 14 players.

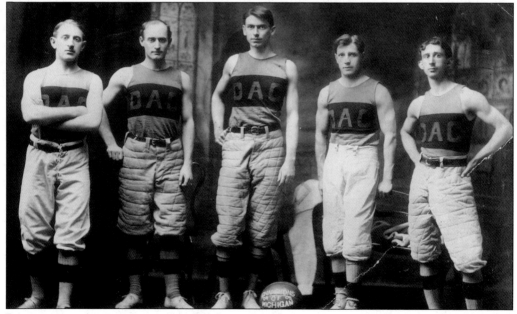

BASKETBALL ARRIVED AT THE DAC IN 1903 AND BY 1904 EARNED A MICHIGAN CHAMPIONSHIP. The DAC's gymnasium was built before basketball was invented. It was 1903 when a group of five athletes wanting to represent the club in basketball put the DAC on the basketball map. The team had honed its skills playing for Detroit's YMCA. The following year, the five (there were no substitutes) played Yale and Notre Dame and won the State of Michigan Championship. Jacob Mazer (far left) was one of Detroit's basketball pioneers.

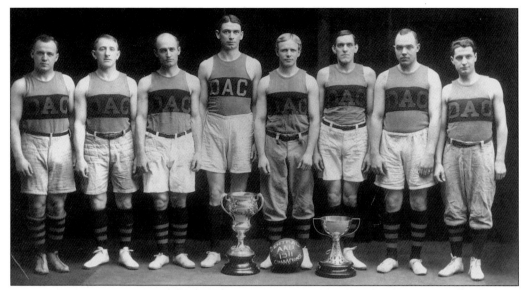

AMATEUR ATHLETIC ASSOCIATION 1912 CENTRAL REGION CHAMPIONS. Nine years after beginning basketball at the DAC, three of the founding members were still playing and winning. Unfortunately, the Detroit Athletic Club was near the end of the first phase of its existence. The 1911–1912 group shown here was the last to represent the club in organized team competition. However, the club would, in short order, reorganize and evolve into today's DAC.

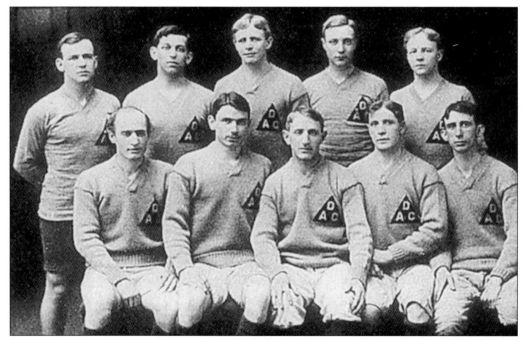

IN THE EARLY 1900S, THE BASKETBALL TEAM HAD DOUBLED IN NUMBER. Seated in the first row in this team picture are Fred Shinick, Dr. C.B. Lundy, Jacob Mazer, John Richards, and Clarence Lidington. As hairlines receded and the years piled up, the original five apparently felt the need for additional help during games. There are no records of this team's achievements, but the fact that team size increased would indicate a continued club interest in the sport.

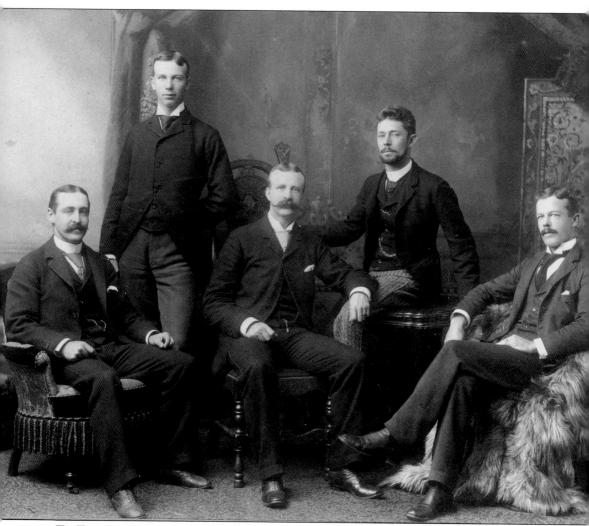

TO THIS DAY BOWLING IS A MAJOR SPORT OF THE DETROIT ATHLETIC CLUB MEMBERS. The 1889 amateur champions, from left to right, are as follows: George O. Begg, Emery W. Clarke, George J. Bradbeer, Richard Raseman, and William Craig. Many of the bowlers participated in other sports, as did other DAC athletes. For example, of the bowling champions pictured here, George O. Begg had played baseball on the team that became the DAC, as did George J. Bradbeer, Emory W. Clarke, and William Craig, who, in addition to bowling, also played DAC football. As the original DAC withered away in the early teens of the last century, bowling all but disappeared. However, when the present DAC clubhouse opened in 1916, members regained an interest in the sport. In fact, interest was so great that in the spring of 1916, DAC teams staged a coast-to-coast tournament with a dozen other athletic clubs across the country. Each club bowled on its home alleys, with scores transmitted by telegraph wire after every frame. The DAC came in a close second to the Seattle Athletic Club, but was clearly a winner in the use of technology.

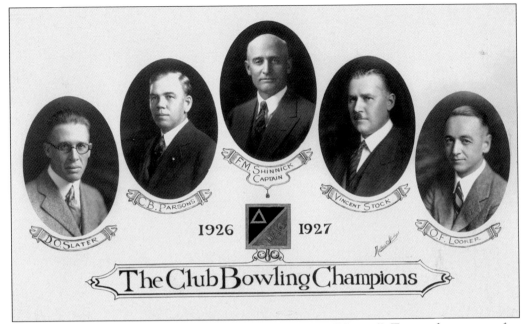

The Club Bowling Champions

1926 1927

D.O. Slater — C.B. Parsons — F.M. Shinnick Captain — Vincent Stock — O.F. Looker

DETROIT ATHLETIC CLUB ATHLETES STAYED IN THE "GAME." Twenty-four years after launching the Club's basketball activity in the original DAC, Fred M. Shinnick captained its 1926–1927 championship bowling team in the "new" DAC. His longtime participation in bowling, at a high level, is indicated by his chairmanship of the total activity in 1917–1918, and by his individual Club high-average championships from 1930 through 1933, individual Club singles championship in 1930, and doubles in 1929 and 1931.

THE DAC'S 1887 MISSION STATEMENT: "THE ASSOCIATION SHALL BE TO ENCOURAGE MANLY SPORTS AND PROMOTE PHYSICAL CULTURE." Over the years, the original intent has broadened to include and encourage female member participation. While the original Club was narrowly focused on intense team and individual athletic competition, the "new" Club's stress was more on individual participation and fitness. Shown here are a few examples, from the Club's trophy case, of awards, old and new, gathered by the DAC.

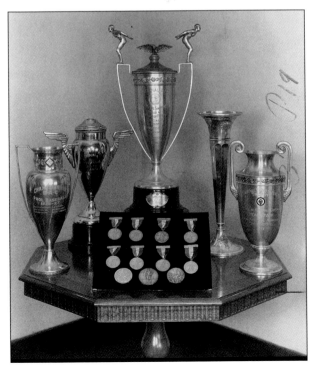

57

THE IN-HOUSE DETROIT ATHLETIC CLUB BOWLING LEAGUE IS ONE OF THE LARGEST IN MICHIGAN. The popularity of DAC bowling is due largely to the camaraderie of the participants. DAC bowling teams last for years and hone members' skills. Joseph F. Paulus, second from the left, has held the individual high average championship 14 times between 1961–1991, was doubles champion twice, has served as bowling chairman, and is still an active participant. The rest of these gentlemen have been honored as members of the Club's Bowling Hall of Fame.

DAC MEMBER BOWLERS HAVE A WIDE RANGE OF INTERESTS. Dawson Taylor, who was high-average champion from 1956 through 1958, and again in 1968, managed a large-volume automobile dealership. Other high-average champions have included medical doctors, auto body suppliers, professional sports team owners, construction materials suppliers, insurance executives, marketing practitioners, accounting services executives, and attorneys. In fact, DAC bowlers mirror the wide range of occupations of its members.

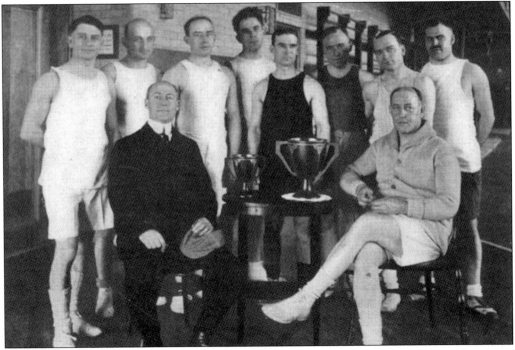

HANDBALL, A DAC CORE GAME, ATTRACTED THE NATION'S BEST PLAYERS IN A DECEMBER 1918 TOURNAMENT. The club's handballers invited top players from other clubs to test the DAC's best in singles and doubles. It was close, but the DAC was the overall winner. The participants were, from left to right: R. Lee Henry and E.V. Tomlinson, DAC; New York's Edward Groden; Brooklyn's Owen Brady; Cleveland's Fritz Seiverd; and William Hawley and A.J. Machen from Toledo; (seated) DAC tournament organizers Dr. F.H. Greusel and D.B. Duffield.

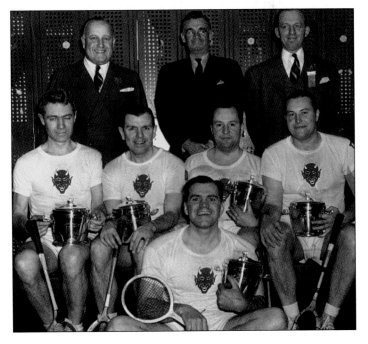

SQUASH RACQUETS HISTORY AT THE DAC GOES BACK OVER 80 YEARS. In April 1942, for the first time in the history of the game, the national championship trophy was carried west of the Allegheny Mountains, a DAC team achievement. The champions, from left to right, were as follows: (front row) Joseph T. Hann; (back row) R.J.D. Standish, Ernest Cockill, and Hal Smith; (seated) Jerome J. Taylor, T.L. Golbart, John Reindel, and William Croul. The DAC beat teams from Pittsburgh, Philadelphia, and New York.

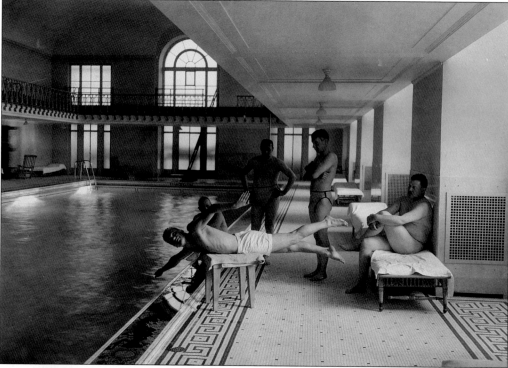

DAC's Natatorium, in Daily Use for Recreational Swimmers, Sometimes the Site of National Competitions. The DAC's first swimming instructor, H. H. Corsan, shown here with a minimal training aid, demonstrates the crawl stroke to a group of members. Architect Albert Kahn positioned the 91,000-gallon swimming pool on the fourth floor of his 1914 design for the "new" DAC clubhouse with an eye to easier inspections, maintenance, and necessary periodic draining and cleaning.

Olympic Champion Clarence Pinkston Came to the DAC as its Swimming Instructor. Known as "Pink" within the Club, Pinkston was well known in Detroit. In addition to an Olympic Gold Medal in 1920, he had also won the AAU National Championship held in Detroit in 1923. Pink's wife Betty, herself an Olympic Gold Medal winner, swam in many DAC events; together they popularized swimming within the Club. The DAC has from its beginning provided its members with top quality sports instructors.

OLYMPIC DIVING WAS ONCE TAUGHT AND PRACTICED AT THE DAC. With swimming instructor Pinkston's and his wife's Olympic Gold Medal experience, it was natural that DAC members would be interested in the sport. It is believed that this photo shows Betty Pinkston on the Club's diving board. The board was on the second level of the natatorium, the same level as the running track circling the pool, and has since been removed. (Courtesy of the Walter Reuther Library in Detroit.)

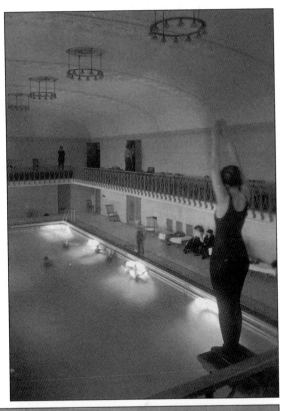

THE FIRST DAC TEAM TO WIN THE "DR. ROGERS TROPHY" FOR DISTANCE SWIMMING, DECEMBER 1918. Standing at the far left is swimming coach Matt Mann, who was hired in December of 1918, and in four days put together a team of DAC swimmers that beat the YMCA team, a feat never before accomplished. The DAC distance swimming team won the Dr. Rogers Trophy three years in a row, which then became the property of the DAC.

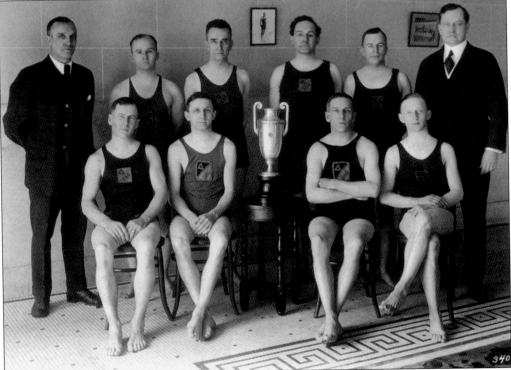

SWIMMER BILL PREW, A WORLD-CLASS DAC SWIMMER. Prew was the co-holder of the world record for the 100-yard free style with Olympic Gold Medal winner and movie star Johnny Weissmuller. Prew was also the NCAA and the AAU champion in the free style. Coach Matt Mann had other swimming arrows in his quiver as he worked with DAC members to prepare for the 1920 Olympic Games in Antwerp. Alas, Ted Cann, the club's best chance, broke his leg and never swam again.

CLUB SWIMMERS WERE FOR YEARS TOP COMPETITORS. Clark Scholes, shown here, a former DAC juniors swimmer, continued on to become the National Intercollegiate 100-yard free style champion in 1950–1952, and an Olympic Gold Medal winner in 1952. Olympic Gold Medal Winner coach Pinkston and his wife Betty, who won her own Gold Medal in the 1928 Olympic Games, were the core of DAC swimming activities. Few athletic clubs in the nation could boast of two Gold Medal winners as swimming instructors.

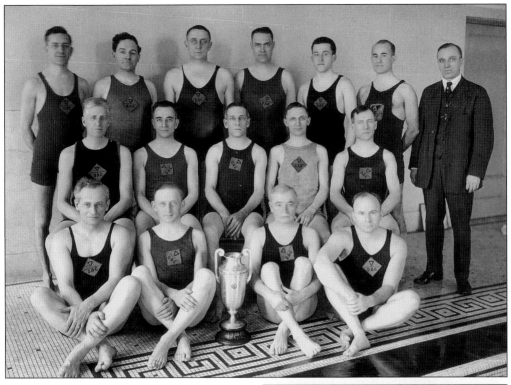

DAC Swimming Champions Were of All Ages. Gathered around the Dr. Rogers Trophy were the 1918–1919 winners. Identified in this photograph, from left to right, are: (back row) Ed Laitner, Burt Eustice, Jim Ballard, Don Dickinson, Art Williamson, and Coach Matt Mann; (middle row) Dr. Jeffries, Paul Henning, and Ben Jeffries; (front row, seated) Dr. Grant, Chris Brandt, Judge Reid, and McCallum. Swimming must have had a good effect on this group of mature competitors.

DAC President, Detroit Tiger Owner Frank J. Navin. In the bylaws of the original DAC, any association with professional athletics would be grounds for exclusion. Over time, ideas changed. When the Detroit Tigers entered the American League, the old DAC was near death. The Tigers quickly captured the baseball hearts of Detroiters and swept away the tawdry image of professional sports. Frank J. Navin's quality presentation of the game and his own impeccable reputation gave the city a lasting legacy.

WORLD FAMOUS GOLFER WALTER HAGEN LIVED AT THE DAC. Hagen, whose obituary read, "He's in golf to live—not to make a living," did earn a very ample living. He won the U.S. Open twice and the British Open four times. The recent movie, *Bagger Vance*, is a fictionalized version of an actual 1926 match between Hagen and Bobby Jones. Reportedly posted for slow payment of his DAC bills, he said, "Good, it shows how much I spend around here."

LADIES' BADMINTON WAS A MAJOR ACTIVITY IN 1941. Shown are the teams from the DAC and their opponents from the Grosse Pointe Neighborhood Club. The DAC ladies were able to win just one match on their home court but, according to the reports of the day, it was a better outcome than their first meeting. In spite of the perception of being just a men's club, the DAC has always provided facilities for women and encouraged their use of the club.

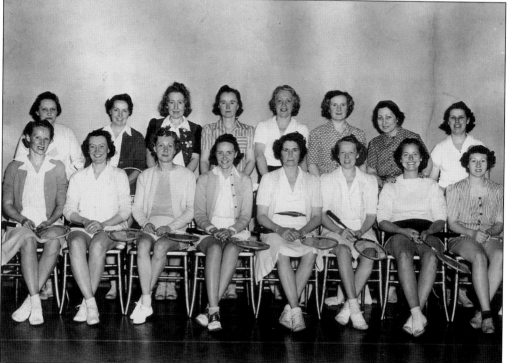

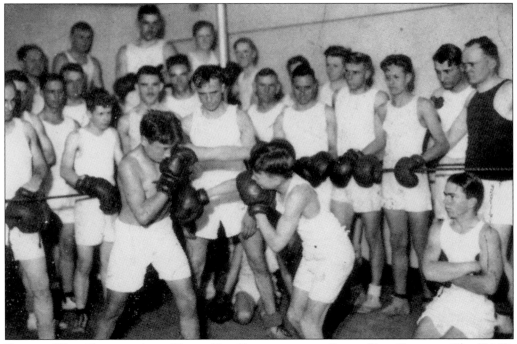

BOXING WAS TAUGHT AS A HAND-EYE-COORDINATION SPORT FOR YOUTHS. The DAC's boxing instructor Fred Hammond carefully instructed groups of boys in the skills of the sport sometime in the early 1920s. His emphasis was on the development of quickness and basic moves rather than trying to develop "champions." The class was usually attended by 20 or so sons of DAC members. In those days, in the city that claimed Joe Louis as a native son, boxing had a wholesome manly aura about it.

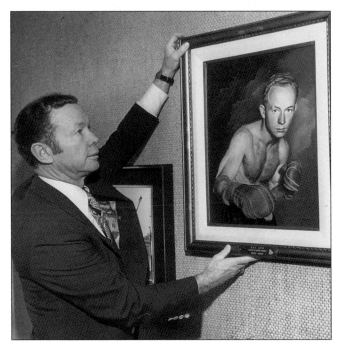

CHUCK DAVEY, A DETROIT ATHLETIC CLUB MEMBER SINCE 1960, IS THE ONLY BOXER TO WIN FOUR NCAA TITLES. Davey, while boxing as an amateur for Michigan State College, set a collegiate record yet to be beaten. He then went on to box professionally in televised bouts in the early days of the sport on TV. Overall, he was 91-1 as an amateur and 40-5-2 as a pro. Davey, since his retirement, has been elected to the Michigan, Michigan State, and Boxing Halls of Fame.

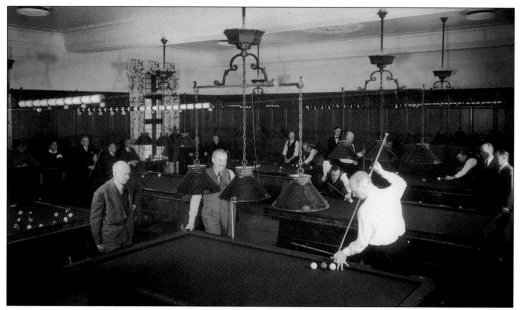

BILLIARDS, THE KING OF THE TABLE GAMES, A DAC ACTIVITY SINCE 1888. The clubhouse of the original club had a separate billiards room equipped with three Schulenberg tables. The above photo shows the billiard room in architect Albert Kahn's current clubhouse; the room was on the west side of the ground floor. Note the two pocketless billiard tables in the foreground and the pocket pool tables at the left. This area is now a fine dining room.

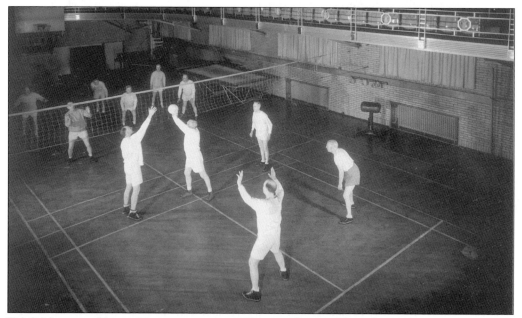

DAC MEMBERS USING VOLLEYBALL AS A FITNESS SPORT. This photo of a game in progress shows the gymnasium before its recent restoration. The tall arched windows, the same as in the swimming area, had been covered and are now restored to their former glory, letting the light in and revealing a view of the new Detroit Tiger stadium next door. With fitness on the minds of current DAC members, the gym provides a locus for today's low impact games.

Four

PEOPLE OF THE DAC

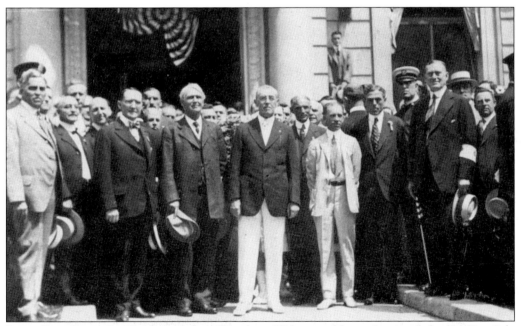

FIRST PRESIDENTIAL VISIT. President Woodrow Wilson and his wife visited the DAC in July 1916, in conjunction with the president's appearance at the World's Salesmanship Congress in Detroit. Here Wilson stands on the DAC front steps with member Henry Ford (to Wilson's left) and Detroit Mayor Oscar Marx. This is just a small portion of a larger photo that shows hundreds of salesmen crowded together for their picture in front of the DAC. Club rules prohibiting woman above the fourth floor were relaxed for the First Lady that day.

SUPER SALESMAN AND CLUB PRESIDENT. Abner E. Larned, who became the fourth president of the Club in 1920, played an important role early on when the Board needed to raise money to finance the Club. Larned's eloquence at a meeting of the entire membership—he also had the doors locked after dinner—persuaded the members to purchase $600,000 in bonds to fund the Club construction project already underway.

TIGERS OWNER AND DAC PRESIDENT. Walter O. Briggs, sixth president of the DAC in 1923, was well known in Detroit as the second owner of the Detroit Tigers baseball team. He purchased the team in 1938 from another DAC member, Frank Navin, which led to the renaming of the team's ballpark to Briggs Stadium. Briggs Stadium later became the beloved Tiger Stadium.

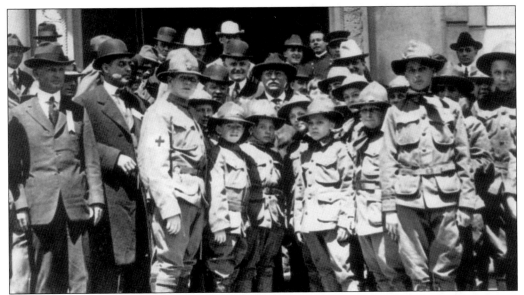

A Bully Day at the Club. Colonel Teddy Roosevelt visited the DAC in the spring of 1916 as part of a campaign stop (he was running against President Wilson). Roosevelt (he's the gentleman with the walrus mustache) is flanked by volunteers, young and old alike. DAC President Hugh Chalmers is to Roosevelt's right (with Abner Larned just behind him). A grand reception was held for the ex-president in the gymnasium, and Roosevelt admired one of the Club's elephant sculptures by Carl Akeley.

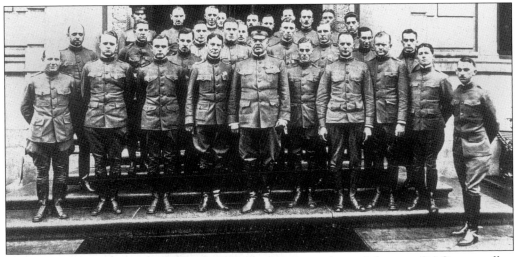

DAC Soldiers Receive Send-Off by Club. Many members of the new DAC went off to fight in France during World War I—a special roster board listing them was continually posted in the Main Lobby. In this photo, Major General Dickman (center) stands with DAC soldiers on the front steps of the clubhouse.

CHARTER MEMBER, DISTINGUISHED GENTLEMAN. John D. Morphy, a charter member of the DAC, clearly shows the elegance and grace of a businessman's attire during the early years of the 20th century. Morphy, an athlete and member of the original club on Woodward, was well known in the insurance business. He was also a longtime advertiser in the Club magazine.

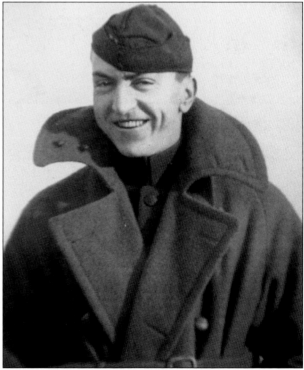

THE CLUB'S FIRST HONORARY MEMBER. Captain Edward "Eddie" Rickenbacker, America's greatest World War I flying ace, was made the DAC's first honorary member by a unanimous vote of the Board on December 16, 1919. Rickenbacker was considered a Detroiter "by adoption," by many in the city. He shot down 26 German airplanes during the Great War and became known as America's "Ace of Aces."

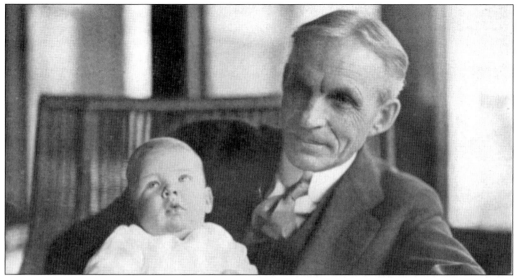

AMERICA'S AUTOMOTIVE GIANT. Henry Ford, America's legendary automobile manufacturer, was not a charter member of the DAC but is listed in the Club's first roster of members when the new clubhouse opened in 1915. This rare photo appears in the *DAC News* with the caption "First photograph of the 'Two Henrys'—Henry Ford I and II." It accompanies a poem written by Edgar Guest entitled "Comrades."

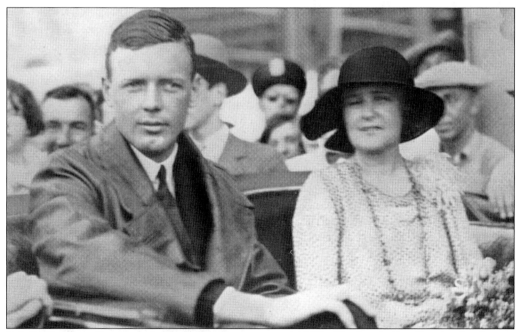

DAC HONORS CHARLES LINDBERGH. In August of 1927, Charles A. Lindbergh, the first to fly the Atlantic solo nonstop, was made the DAC's second honorary member. An honorary membership was also given to Lindbergh's mother. DAC President Arthur Waterfall, in his remarks, noted that the DAC had been "headquarters for the movements to make Detroit the center of the country's aviation industry." That same year, the Club retired its first mortgage bonds and the first DAC president, Hugh Chalmers, symbolically threw them into the fireplace.

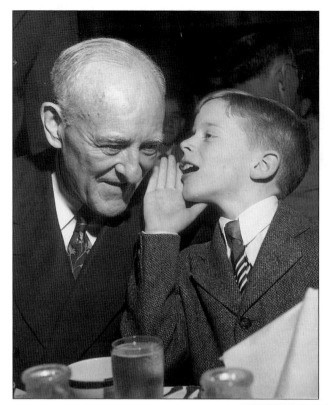

"Mr DAC." This image of Charles Hughes and his grandson Bruce Gillis was taken in 1953 at the Father and Son Party shortly before Hughes' death. Hughes sat as Club secretary from 1913 until 1953, also running the Club magazine during that entire era. A University of Michigan graduate, Hughes held various newspaper and magazine jobs before turning to advertising and marketing. The first issue of his new DAC magazine appeared in January of 1916.

Oldest Magazine in Michigan. *The DAC News* still wears that title with honor. Hughes' goal was to create a first-class publication that covered Club news but also offered a venue for American writers and artists. The roster of contributors reads like a who's who of early 20th century writers and artists. James Thurber, Ring Lardner, Robert Benchley, Dorothy Parker, Walter Winchell, Groucho Marx, John Held, Arthur C. Clarke, Edgar Guest, and many others have graced the pages of a publication that today continues its own award-winning tradition.

A DAY AT THE SERIES. Charles Hughes enjoys an afternoon at the Detroit Tigers World Series of 1940. He's seen here in Briggs Stadium along with other DAC members Arthur Winters, Henry Ewald, and Harvey Campbell. Ewald was a founder of a major advertising agency in Detroit, Campbell-Ewald. The Campbell here was not Ewald's partner but president of the Board of Commerce.

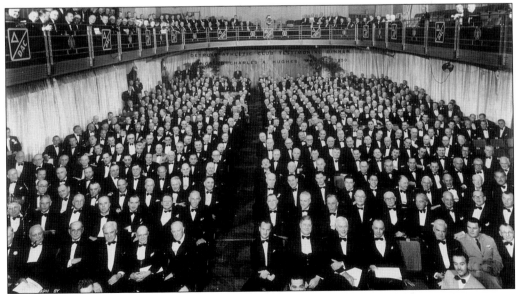

LOVE FOR A GREAT MAN. Hundreds of members of the DAC filled the clubhouse gymnasium in May 1950 for a testimonial dinner honoring Charles Hughes (seated sixth from the left in the first row). The black tie affair featured a floorshow with Frank Fay, Jane Froman, Bert Wheeler, and Ken Whitmer. Speakers included the presidents of both General Motors and Chrysler at the time. Hughes died three years later on a train bound for Miami following the Club's annual election.

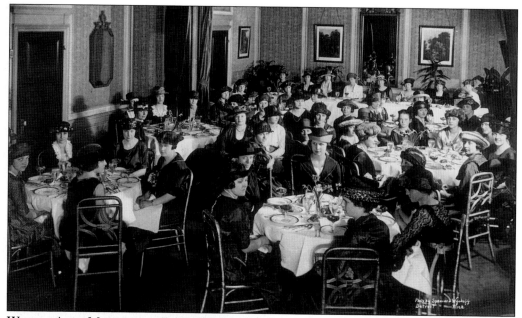

WOMEN ALSO MET AT THE DAC. While women were not allowed in many parts of the Club during the early years, they enjoyed their own entrance and a suite of rooms and dining areas. This rare 1919 photo shows a reunion party of the alumni of Bryn Afon in Rinelander, Wisconsin, who gathered in the second-floor private dining suite. Fanciful hats were the order of the day.

A DAC LEADER DURING THE ROARING TWENTIES. William E. Metzger was a charter member of the DAC and its fifth president (1921–1922). During his reign, the French hero of World War I, Marshall Foch, visited the Club and the DAC purchased a piece of property known as Cross Street, which was behind the clubhouse. Metzger was the last man to serve more than one term as DAC president.

PRESIDENT JUST BEFORE THE CRASH.
B.F. "Barney" Everett was president of
the DAC in 1928. During Everett's reign
as president, the Club's inter-club group
known as the Beavers first launched
the grand tradition of the Father and
Son Party, an event that still draws
500 members and their families to the
clubhouse each November. Everett was a
founder of E.M.F. Motor Cars along with
William Metzger and Walter Flanders,
both DAC members.

THE START OF TOUGH TIMES.
Charles T. Fisher became the Club's
13th president in 1930. With
the Depression quickly setting in
following the crash of 1929, the
DAC suffered the poorest first
month the Club ever had with a
deficit of over $7,000. The Club
was to endure five years before
operations were returned to a
profitable state.

75

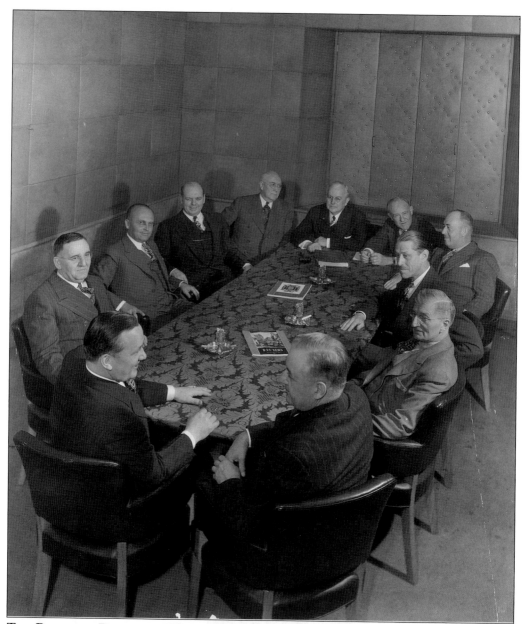

THE BOARD OF DIRECTORS. The Detroit Athletic Club bylaws call for the organization to be governed by a Board of Directors (that today numbers 18). The Board itself is led by an executive committee, which is made up of the president, the first and second vice presidents, the secretary, and the treasurer. The line of succession to the presidency goes from the president to the first and then second vice presidents, with a new second vice president elected each year from the incumbent candidates. Board members can serve two consecutive three-year terms. This unique photo taken at the height of World War II (in 1943) shows a typical directors meeting. Present around the table are board members, clockwise from front: D. Lyle Fife, C. David Widman, Harvey C. Fruehauf, J. Edgar Duncan, M.E. Coyle, President Carl Breer, Charles A. Hughes, E.W. Ross, Clarence E. Otter, Arthur Winter, and Harvey Campbell. Note the copies of the *DAC News* on the table.

SO MANY FAMILIES, SO MANY GENERATIONS. Lloyd Diehl Jr., like many members of the Club today, is one of several generations of DAC members. This photo was taken in 1940, when he joined. Diehl's father, Lloyd Diehl, had become a member in 1933, and sat on the Board in the 1950s. Like his father, the younger Diehl was elected to the Board and later chaired the Facilities Committee for 17 years. A third generation Diehl, Lloyd Diehl III, became a resident member in 1984.

CHEVROLET AND THE DAC. Thomas H. Keating was elected as the 34th president of the Club in 1952. At the time he was also general manager of Chevrolet Motors. During Keating's time as president, the DAC purchased its own parking garage. The ceiling of 3,000 resident members was topped by a waiting list of over 700 names. Keating also oversaw a fairly extensive modernization program throughout the clubhouse that was then 37 years old.

77

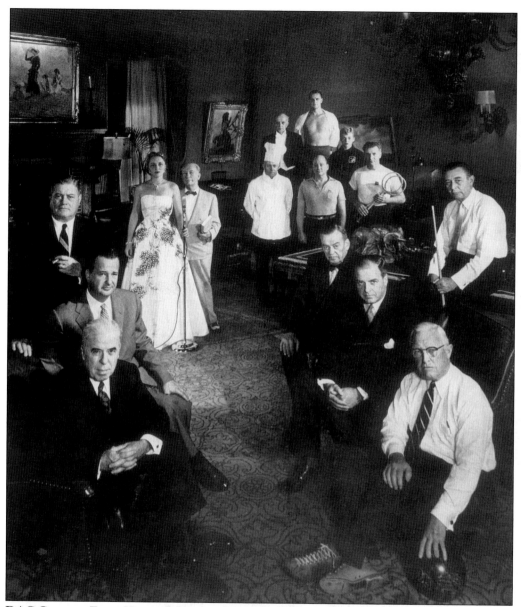

DAC Classics From Holiday. In one of the more unusual photos taken at the DAC, this image for *Holiday* magazine comes from 1954. It ran with a story on the Club and included an extensive caption that said the DAC was "heavy with names of prominence and substance." Among those pictured are: Thomas Milton, a famous old-time race driver, seated third from the right; Clarence Pinkston, DAC athletic director and Olympic champion, standing in back between DAC executive chef Louie Moresi and squash pro Joseph Krinock; Jeanne Stunyo, one of America's top springboard divers, standing behind and to the left of Pinkston; Edgar Guest, Detroit and DAC poet laureate, standing next to Metropolitan Opera soprano and DAC entertainer Jean Fenn (holding microphone); and Benson Ford, vice president of Ford Motors, seated at left behind T.H. Keating, in front; and K.T. Keller, a Chrysler tycoon (behind Ford). Also pictured are DAC world-record swimmer William Prew, Club President William Mayberry, Martin Callahan, Joseph Bayne, and Michael Annis. Arnold Newman took the image for *Holiday*.

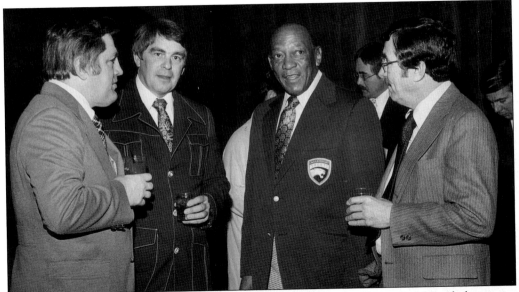

BEAVERS SPEAKERS INCLUDED RENOWNED ATHLETES. The Beavers, one of the major clubs-within-the-club at the DAC, were founded in 1919. Today the group numbers close to 1,000 members. The Beavers play a game called "basketbrawl" and host guest speakers, including the likes of Olympic track legend Jesse Owens (seen at center in this 1970s photo), to their weekly lunch meetings.

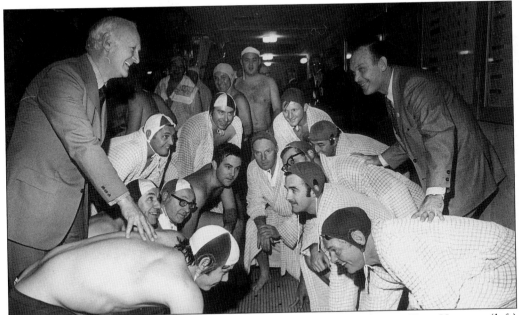

ANOTHER BEAVERS' FUN PHOTO. Football immortals from Michigan, Tom Harmon (left) and Forest Evashevski (right), line up their respective teams of DAC Beavers for a showdown poolside. The teams, the Snappers and the Barracudas, were fighting it out for first place in the Beavers "basketbrawl" league. Olympic swimmer and DAC member Clark Scholes crouches at center below longtime member Walker Mayhew. Some of the other gridiron Beavers pictured, from left to right, are as follows: Jack Bartlett, Bill Wells, Mick Miller, and more.

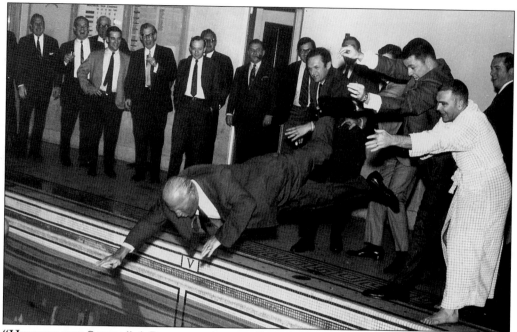

"HITTING THE SAUCE." A Beavers tradition calls for the dunking of new officers to the group, as well as the newly elected presidents of the Club. In this image, Beavers President Andy Brodie "hits the sauce" during the Beaver stag party, in April of 1969. Among those helping make the dunking happen are Jim LoPrete, Jim Sullivan, and George Valassis.

THE CLUB CELEBRATES 60 YEARS. The Detroit Athletic Club celebrated its 60th anniversary (in the Madison Avenue clubhouse) in October of 1975, with a major party that drew hundreds of members including eight 60-year members. Then General Motors president Roger Smith can be seen at this table (seating third from the left), while Chrysler Chairman John Riccardo is seventh from left at the table.

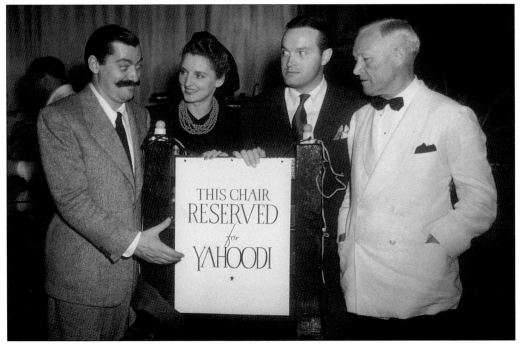

BOB HOPE HONORED AT THE DAC. Bob Hope was among hundreds of well-known entertainers to perform at the DAC. He is seen here with Jerry Colonna, his wife Dolores, and Prexy Callahan at a DAC party in Hope's honor. Other famous visitors include Bing Crosby, Will Rogers, George M. Cohan, Victor Borge, Edgar Bergan, Ed Sullivan, Fanny Brice, and Billy Sunday, to name a few. Harry Houdini gave a spirited lecture at the DAC in 1924, and many other speakers, including Amelia Earhart in 1932, have entertained DAC members.

WEISSMULLER USED DAC POOL FOR WORLD RECORD. Swimming legend Johnny Weissmuller set a new world's indoor record in the DAC pool in April of 1922. Weissmuller, who went on to Tarzan movie fame, smashed the 220-yard freestyle record of the time and won the national AAU championship for that distance. In this image Weissmuller, who swam for the Illinois Athletic Club, is seen standing second from the left.

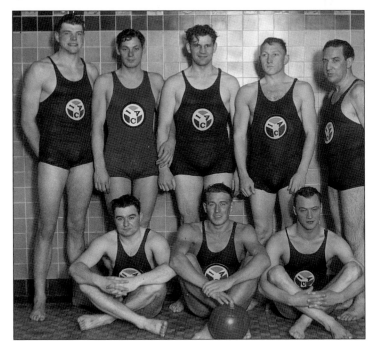

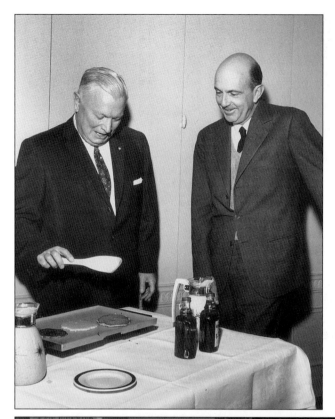

DAC Hosted Kings as Well as Presidents. Besides famous entertainers and presidents of the country, the DAC was known to have a king or two visit over the years. Here, DAC member Walker Cisler cooks up a pancake breakfast for King Umberto di Savoia of Italy in October of 1963.

Another Royal Visitor. Swedish King Carl XVI Gustaf, on a bicentennial tour of the United States, visited the DAC in April of 1976. The young king (seen second from left) attended a luncheon at the DAC hosted by the Detroit Swedish Council. He was joined by Michigan Governor William Milliken, Henry Ford II, and Chrysler Chairman John Riccardo.

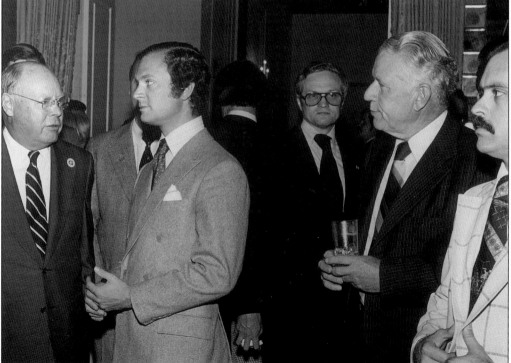

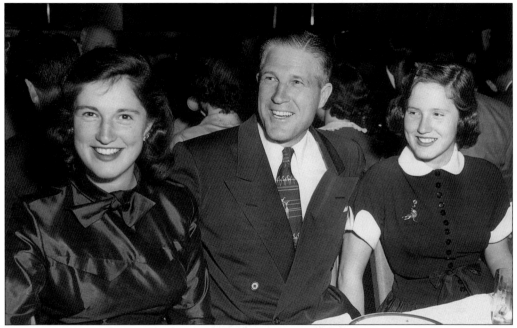

THE FATHER AND DAUGHTER PARTY. Another beloved DAC tradition over the years has been the annual Father and Daughter Party. In this April 1953 photo, a young George Romney enjoys the event with his daughters, Lynn and Jane. Romney, a DAC member, was later to become governor of Michigan.

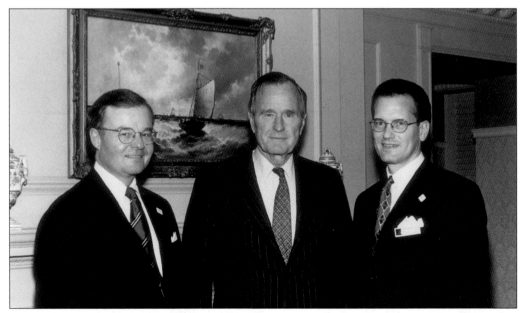

PRESIDENTS KEEP ON COMING. Former President George Bush visited the DAC in November of 1997 in his role as honorary chairman of the World Golf Foundation's "the First Tee" initiative. Bush is seen here with then DAC President Doug Rasmussen (left) and DAC Executive Manager J.G. Ted Gillary (right). Following in his father's footsteps, the younger Bush, George W., visited the DAC in 2000 during his presidential election campaign.

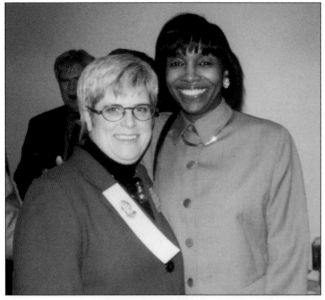

HISTORY IN THE MAKING. The DAC began admitting women as resident (and voting) members in 1986. Then, in a historic moment for the Club, Mary Kramer became the first woman elected to the Board of Directors in 1998. Three years later, during the 2001 election balloting, Kramer won the runoff for the position of second vice president, putting her in line to become the Club's first-ever woman president in 2003. Kramer is seen here, immediately after the monumental vote, being congratulated by fellow member Linda Watters.

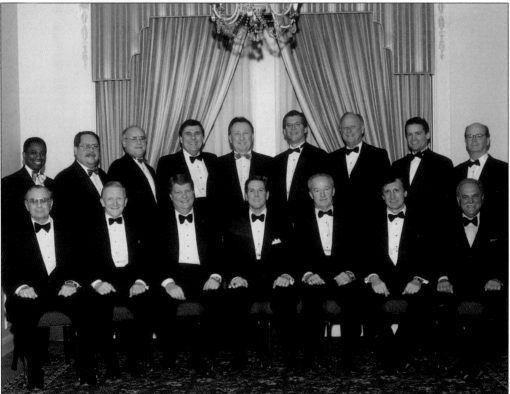

A BOARD FOR A NEW ERA. This is the DAC Board of Directors in 1998, more closely reflecting the diversity of the Club, a group that also led some of the major restoration efforts to revitalize the DAC. Newly elected Board member Mary Kramer was not present for this photograph, but six from this group will wear the mantle of Club president, including Thomas Quilter, Terrence Keating, Thomas Wolfe, Charles Nicholl, and Vincent Butterly.

Five

SOCIAL EVENTS AT THE DAC

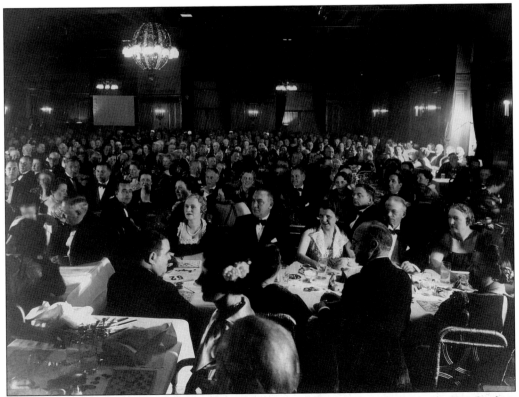

BLACK TIE AND BINGO. The annual Keno parties were especially popular at the DAC when this photo was taken in 1938. Held every year almost from the opening of the new clubhouse, Keno (never called Bingo back then) was abandoned after the 1940s due to changes in the law regarding such parties. Elegant dresses and tuxedos were the order of the day. This image was taken in the Main Dining Room.

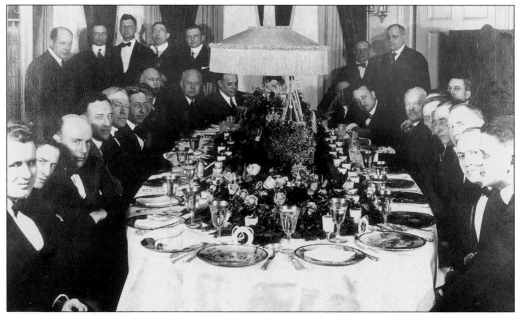

LAVISH PARTIES WERE THE ORDER OF THE DAY. This small gathering was typical of the parties in the early 1920s at the DAC, with French linen and fine china. Although it's not exactly clear why these gentlemen are meeting, it may actually be a Board meeting or party. Frank Navin, one of the owners of the Detroit Tigers and a DAC president in 1925, is seated at the table in the back along with several other prominent early members.

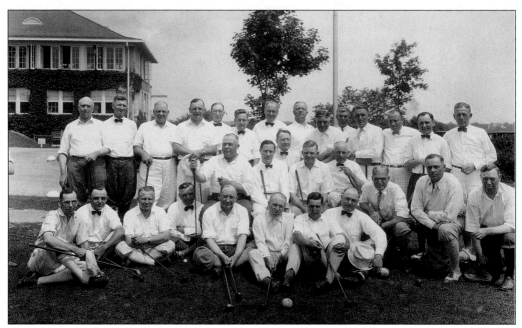

BOW TIES AND GOLFING REGALIA. These DAC members are out for an afternoon on the links, likely at the Detroit Golf Club. The fashion of the day called for clean, pressed white shirts, bow ties, and knickers. DAC members have long enjoyed the game of golf, hosting numerous Club tournaments during the early days.

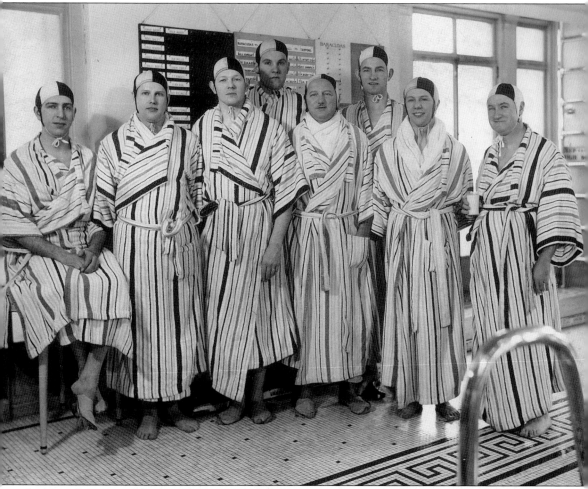

STRIPED ROBES AND BATHING CAPS. The Beavers club-within-the-club at the DAC has been around since the group was first formed in 1919 by Edward Laitner, one of 14 charter members and the group's first president. This group of Beavers are the Sharks, the 1941 "basketbrawl" champions, dressed to kill in their striped robes and bathing caps. "Basketbrawl" is a hard fought basket-style game with teams swimming in the water and trying to sink baskets for points. The grueling season generally lasts from October through March, and the games draw both "land" and "water" Beavers. Included in this group photo, from left to right, are: Laitner, Bill Slaughter, John W. McCrae, Bob Klintworth, Dr. Louis Hromadko, Dr. Curtis C. Later, Dick Degener, and Neil D. McGinn.

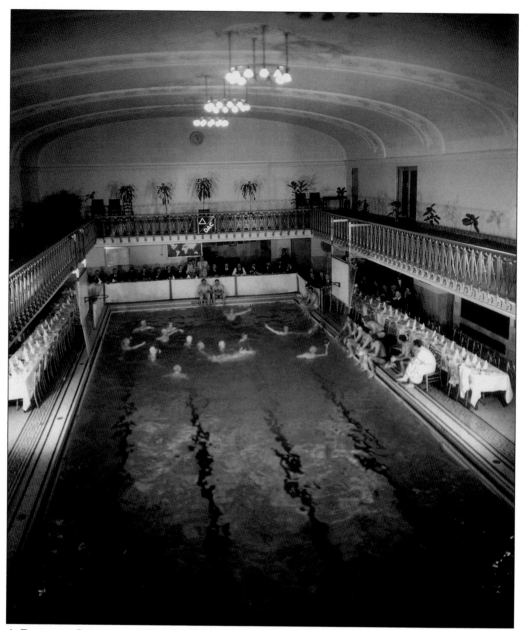

A POOLSIDE LUNCHEON. For much of its time, the Beavers not only held their "basketbrawl" games in the natatorium pool, but the actual luncheon meetings were there as well. This image is from a rare color transparency sometime in the 1940s. Today, the Beavers have spread out into the gymnasium for the luncheons following far more heated battles in the pool than appears to be the case in this photo. Luncheon speakers have included the cream of the sports world in Detroit as well as business and civic leaders. For years, the Beavers' programs were hampered by the echoes in the natatorium. This changed in 1936, when acoustical tiles were added. Thanks to the efforts of the Beavers, the DAC successfully hosted the U.S. Olympic Swimming Trials in 1956.

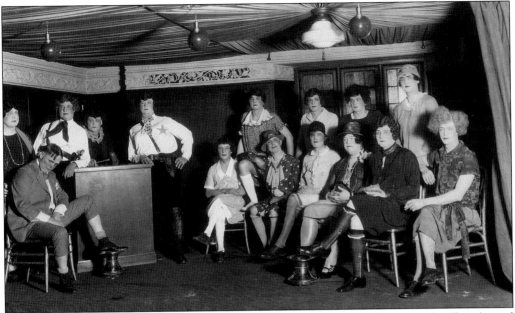

WHEN LADIES WERE NOT PRESENT. The fun-loving Beavers were always (and still are) good for a gag. This motley collection performs a courtroom skit for the 1927 annual Beavers banquet. Some of the members in this photo include, from left to right: Dick Fowler, D. McClintook, Dr. Shafer, Tommy Tomkinson, Leo Kelley, Dr. Becker, Eddie Henkel, Robert Alling, Norm Chamberlain, Walker Laitner, Cy Watts, Clarence Guilford, Dr. Perkins, and Jack Boydell.

BOWLING REMAINS KING. Besides the Beavers, the Bowlers are the largest group within the DAC, and bowling has been present at the new clubhouse since the doors opened in 1915. This group of "bowling fans," so dubbed in a 1939 *DAC News* article, traveled with the DAC team to the Inter-Club Tournament in Cleveland. The Inter-Club has been held every year since 1916 and involved a number of athletic clubs. Today, only the DAC and Cleveland Athletic Club carry on the tradition.

INSIDE THE DAC BOWLING CENTER. The DAC Bowling Center has always been a hub of social activity at the clubhouse. It is here that members bowl and enjoy each other's company with dozens of leagues competing from the afternoon of each day well into the evening. Today, the Club operates the largest private bowling program in the country with more than 900 bowlers in approximately 25 leagues. This is the Friday 8:15 league taken in 1945. The chairs and benches have since been replaced.

THE ANNUAL TOURNAMENT. Each year, the annual Club roll off is held in the spring to determine the best team from among all of the DAC leagues. There is also a singles competition, even though the overall singles champion is determined by average. This photo from 1943 shows the winners of the DAC Open House tournament held in December each year. From left to right, they were as follows: Harry Sigsworth, Horace Dickinson, and George Allen. There were 40 bowlers that year.

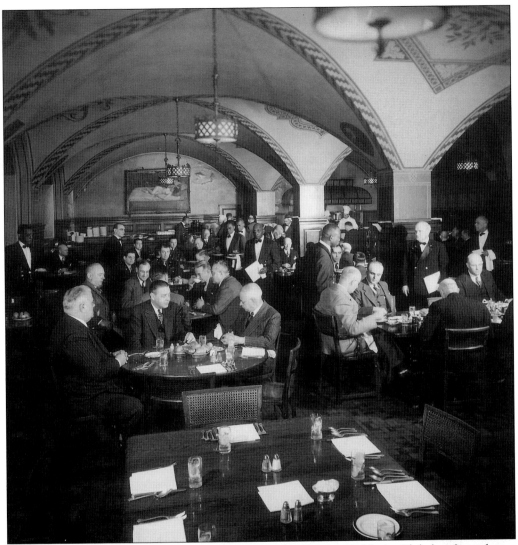

INSIDE THE GRILL ROOM. For nearly 90 years, the Detroit Athletic Club has been home to many of Detroit's business and civic leaders. No place in the Madison Avenue clubhouse was more home to the members, people like the Dodge brothers, Walter Chrysler, Ransom Olds, Henry Joy, Harry Jewett, Alfred Sloan, and John Kelsey, than the Grill Room, designed by Albert Kahn to invoke the aura of the Italian Renaissance. In this World War II-era photograph, members of the Club enjoy a simple lunch in the Grill. Over the years, the Grill has offered jazz and classical music quartets along with outstanding food, fare that today still ranks with the best in the City of Detroit. The Club's bar, the Tap Room, did not exist until 1936, when the billiard room was halved. In those days the bar was in the Grill.

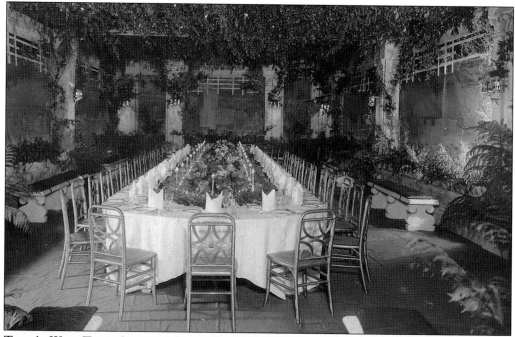

THAT'S WHY THEY CALLED IT THE ROARING TWENTIES. For a private party at the DAC, John F. and Horace Dodge once had the Club pool converted into a Venetian canal with imported gondolas and gondoliers at a cost then of some $25,000. This 1920s image shows the pool hidden by a special covering designed by Albert Kahn to allow social affairs in the natatorium. A fabulous garden trestle overhead and painted canvas around the perimeter added to the beauty of the occasion.

GYMNASIUM ALL DECKED OUT. This is the gymnasium all decked out for the DAC's anniversary party in 1925. Like the pool area, the gymnasium has long been used for Club social affairs, often gaily festooned with flowers, wreaths, and hanging flora treatments. A drop ceiling is also used to create a more intimate atmosphere. With the stage built into the gym in the 1920s, it became a popular place for the nation's top stars to visit and perform before admiring audiences.

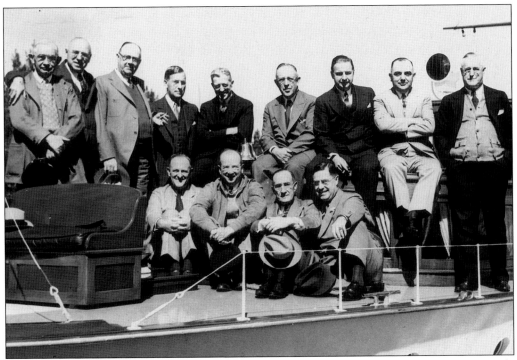

OLD CLUB OUTING. The tradition of the Beavers Old Club Outing goes back to 1937. It's likely these gentlemen are preparing to disembark to Harsen's Island, home to the popular summer event that is usually highlighted by a baseball game between the DAC Bowlers and the Beavers. Believe it or not, formal dress attire was required for many years at the event. Charles Hughes is sitting at left in this photo and William B. Mayo, Ford Motor's chief engineer, is standing at far left.

A CAKE FOR 40 YEARS. The biggest cake likely ever produced at the DAC sparkles in the Main Lobby during the 40th anniversary celebration of the opening of the new clubhouse. That's Club President J. King Harness at the microphone making brief remarks before the cutting of the cake. Harness was celebrating his birthday that very day. The *DAC News* reported that "close to 3,000" people jammed the Club for the event.

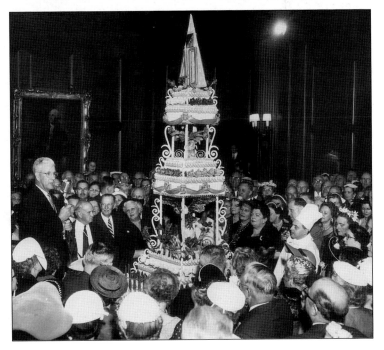

ON THE GRAND STAIRCASE. This is part of the 3,000 people the *DAC News* reported attended the 40th anniversary of the opening of the Madison Avenue clubhouse. Attire was quite mixed, but black-tie seemed to dominate for many of these gentlemen.

THE DAC LOVES ANNIVERSARIES. This is another DAC anniversary—the Silver (25th) of the Club. Here the great Hildegarde performs as a part of a "DAC Follies" presented in the gymnasium. The event included a spoof of the DAC Board of Directors (seen here) called "Unfinished Business," and was presided over by E.A. Batchelor.

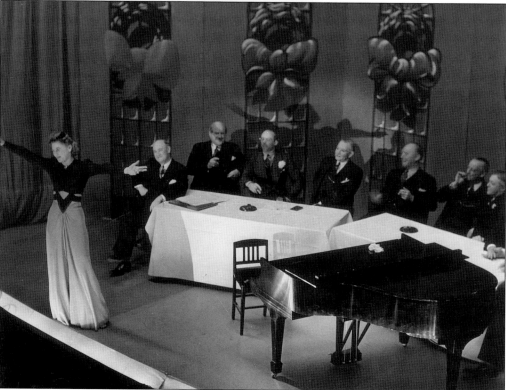

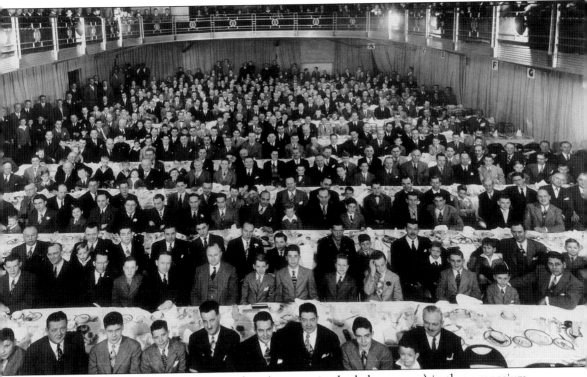

FILLED TO THE RAFTERS. Every seat is taken (even up in the balcony area) in the gymnasium during the lunchtime part of the traditional Father and Son Party. This image was made sometime during the World War II era and should be considered a great accomplishment for the photographer—everyone is looking at the camera and generally appears in sharp focus. The Father and Son Party was first started in 1925 by the DAC Beavers under Henry Vaughan. More than 200 attended that first party and were entertained by a galaxy of sports stars from the Tigers and the University of Michigan. The event traditionally includes a great lunch in the gymnasium after swimming and diving competitions in the pool. At one point the Club actually had two Father-Son events, but they were merged into one and today the party is a club-wide event drawing nearly 500 each year.

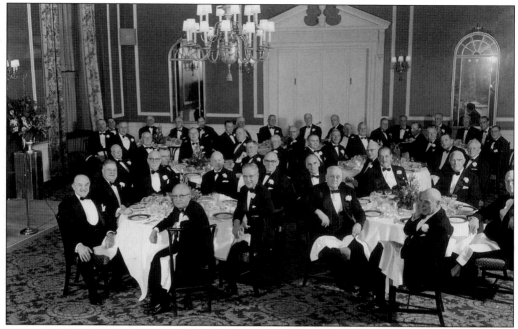

ANOTHER TRADITION AT THE DAC. The Past and Present Directors Party is another DAC tradition. It generally follows the annual election each January. This gathering is from January of 1956, and was taken in the Georgian Room. Note how the photographer was able to make sure no one blocked the view of someone else.

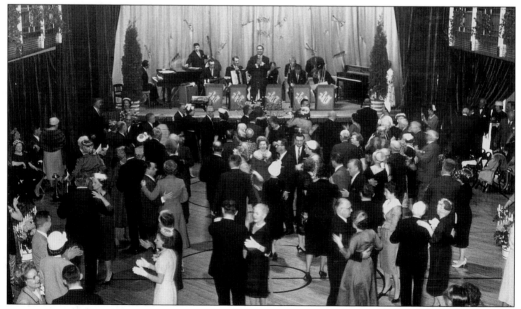

FORTY-FIFTH CLUB ANNIVERSARY. The 45th anniversary of the DAC (in its new clubhouse) was held in the spring of 1960. One of the event's highlights was the performance by Lawrence Welk's Band seen here on stage in the gymnasium. Welks' show drew many admirers including a bevy of ladies seeking his autograph. The stage he performed on no longer exists. Welk was one of hundreds of well-known artists to take to that stage.

DAC GLEE CLUB. The DAC Glee Club (an idea originally suggested by members of the original DAC on Woodward) perform in April of 1940 for the 25th anniversary follies. The group, from left to right, includes: (front row) J.C. Webb, Harry Williams, Harry Wood, Victor Hughes, John Parsons, Leo Rennell, C.L. Boyle, Ross Aiken, A.H. Moorman, Gayard Lafer, G.H. McMahon, and Home Williams; (back row) Harry Curtis, Waldo Fellows, Allan Campbell, Charles Boyd, James Ballard, Herman Joos, Fred Goodson, E.C. Stark, and Lyle Fife.

FATHER AND SON PARTY. DAC member Howard T. Keating distributes Club favors to his three sons at the annual Father and Son Party, this one held in January of 1958. The boys are Kevin (age eight), Douglas (nine) and Howard (ten).

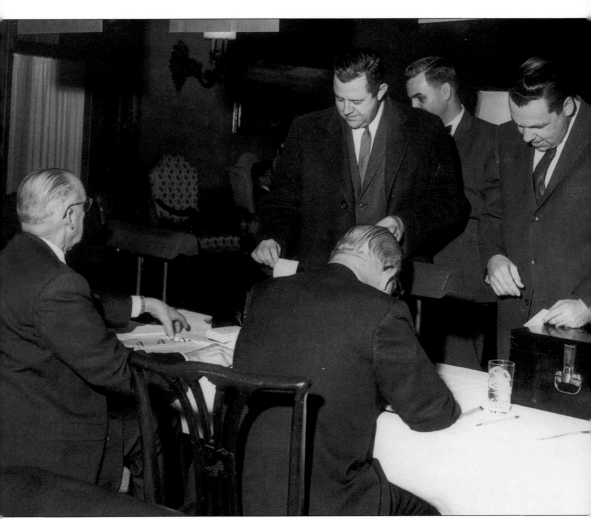

ANNUAL CLUB ELECTIONS. One of the biggest social affairs of all at the DAC is the annual election to the Board of Directors. Usually held at the end of January each year, the balloting lasts all day long—members are required to come personally to the DAC to vote for the Board. Election campaigning is limited but brisk—supporters hand out literature to each voter who passes through on his or her way to the polling station in the Reading Room. There is always a great deal of partying on election day throughout the clubhouse, from the suites on the top two floors down to the meeting rooms on the second floor. Each candidate usually holds court in one of these rooms, seeking to win voters (or just have a good time) through free cigars, drinks or snacks. A free meal is served to all members who show up to vote—prime rib being the order of the day. After the polls close, the ballots are counted in secret and the results announced that same night during the annual Club meeting. In this image, S.E. Milne and Leslie T. Gillmor cast ballots during the 1962 election.

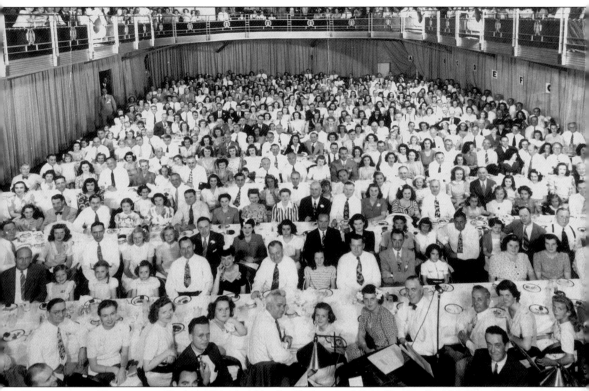

FATHER AND DAUGHTER PARTY. Much like the Father and Son Party, the DAC each year hosts a special Father and Daughter Party. There are games, prizes, gifts, and a special luncheon in the gymnasium. The party began sometime after World War II, when members realized that they had a great event for their sons but no way to showcase their daughters in a more formal setting. Since that time it has become a grand tradition, drawing more than 400 members and their daughters, many of whom have attended year after year after year. This image was taken sometime in the late 1940s or early 1950s. Many of the men have removed their jackets to relax during lunch. Father-Daughter has traditionally been held in the springtime, and girls wore their new Easter or spring outfits.

THE DAC—THE PLACE TO BE. "Back to the Club" night has become the place to be for DAC members young and old alike. These members (including from left Dennis Murphy, Kristen and Barry Winfree, and an unnamed couple) enjoy the festivities in the Main Lobby. Refreshments and entertainment can be found throughout the entire building that night, and nearly all the DAC staff is on hand to welcome the returning members.

HOW THE CLUB SEASON KICKS OFF EACH FALL. Enjoying a new Club tradition that began less than 20 years ago and known as "Back to the Club Night" are, from left to right: Alice Kliber, Frank Stella, Beth and Tom Kliber, and Ralph Kliber. The annual event draws more than a 1,000 members to the Club each September to officially kick off the season of activities at the DAC.

Six

ART AND ARCHITECTURE OF THE DAC

ON LOOKOUT HILL. This work by American artist Frank Weston Benson was acquired in April of 1915, before the new clubhouse opened. The Impressionist painting was in Detroit as a part of a show that was known as "The Ten" group of avant-garde painters. DAC board member Abner E. Larned saw the painting, rushed to a Board meeting enthused by what he had seen, and before the meeting ended, he had gathered the $5,000 necessary to buy it. It was money well spent.

THE CLUB'S *RECLINING NUDE*. Painted by American Julius Rolshoven in 1900 in London, the subject, named "Lily," appeared one day asking to be painted. Rolshoven took three months to complete the work. Later, the painting, bought in New York for $20,000 by Detroiter Marvin Preston, was displayed in his "Churchill's Saloon." Prohibition forced the closing of Churchill's. Preston, convinced that Lily was going to a nearby good home, donated the painting to the DAC in January of 1918.

A GIFT FROM THE CLUB'S FIRST PRESIDENT. President Hugh Chalmers, in addition to serving two terms, enhanced the clubhouse further with the gift of the painting, *The Red Shawl*, at the end of his term of office. The large painting is by Belgian Herman Richir, a distinguished international portraitist. The picture was first displayed at the Panama Exposition in San Francisco in 1915, and has been displayed in the DAC since 1916.

ONE OF TWO PIECES BY REMINGTON. The *Horse Muster*, by renowned American artist Frederick Remington, came to the DAC as a gift. The painting had been on display under loan agreement when the club opened in 1915. During his term as Club president in 1919, Henry B. Joy offered the owner, Carl C. Fisher, $20,000 for the painting, which he declined. When Fisher died in 1929, his will revealed that he had designated the DAC as recipient of the painting.

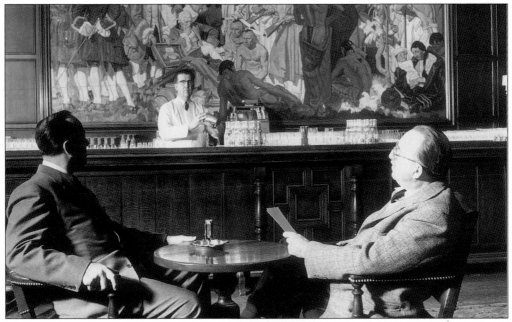

TREATY OF LANCASTER. This work by Dean Cornwell depicts the settling, in 1744, of boundaries of six Indian Tribes and England for all the lands west of the Appalachian Mountains. The location was Lancaster, Pennsylvania. The mural, commissioned by the DAC, is a massive work that has dominated the Club's Tap Room Bar since its installation in 1936. Cornwell was one of America's leading illustrator/artists whose works regularly appeared in national magazines.

103

THE CLUBHOUSE CONTAINS MANY
FINE SCULPTURED OBJECTS. *Victory
Overseas*, the massive, 6-feet high
piece dominates the landing of the
grand staircase. It is the work of
American painter turned sculptor,
Paul Manship, who was highly
respected as a sculptor. Commissioned
by the Club's Art Committee in 1927,
the work depicts Columbia leading
the United States forces into battle
in World War I and was meant to
honor the DAC men who served in
that conflict.

ONE OF THE EARLIEST PAINTINGS
IN THE DAC. *Las Tasse au Chocolat*
was painted by Carle VanLoo, who
was born in Nice in 1705. His early
training was in Rome, where he
achieved wide acclaim. His career
continued to blossom after he moved
to Paris in 1732. VanLoo was named
painter to King Louis XV and was a
professor at the Academie of Paris.
In 1946, his painting was donated to
the DAC.

DAC GRAND STAIRCASE TREASURES.
The wrought iron staircase balustrade
was custom crafted for the DAC by the
famed Samuel Yellin metalworking shop
in Philadelphia. Through the doorway,
the *Bust of Hermes*, which before 1927
occupied the niche in the staircase,
can be seen. The bust was a donation
by Frederick K. Stearns in 1915. The
tapestry (one of two) was crafted in
Brussels *c.* 1725–1750. The Club
members purchased the pair in 1946.

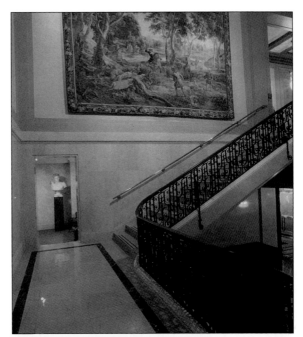

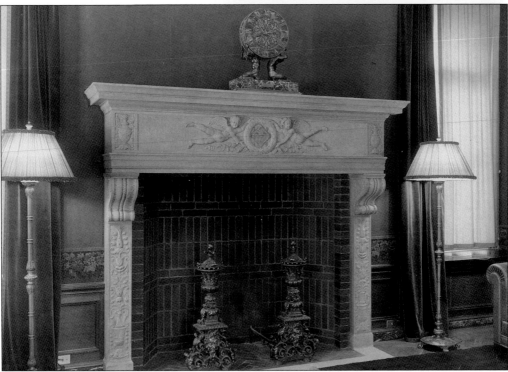

THE FIREPLACE IN THE READING ROOM. Shown here as it appeared in 1919, the fireplace
exhibits a number of treasures. On the mantle is the unique *Ormulu* clock donated to the club
by C.H. Wills, engineer for Ford, in 1915. New York's nationally respected Edward F. Caldwell
designed the fireplace andirons and side lamps. The fireplace itself was an Albert Kahn design
carved by local craftsmen.

PURCHASED BY DAC MEMBERS IN 1918. The painting, *New Haven Green*, is by Frederick Childe Hassam, one of the "Ten Group" that included Frank Benson. Hassam, who had studied in France and was an Impressionist, influenced mostly by Monet and Pissarro. Over the years, he was awarded many significant awards and honors. It is remarkable to consider that early DAC members, with their auto/engineering focus, would commit their money to the purchase of Impressionist paintings.

ANOTHER FORM OF ART WITHIN THE DAC. Shown here in a 1946 photo, is the very "modern" ladies cocktail lounge. Although the room has been reconfigured into a private meeting room, the wall paintings are still intact; but the shiny metal ceiling is gone. At the time of the picture, men could only come into this sanctuary if accompanied by a woman. Another sign of the times was the ashtray on every table.

THE CHANDELIER AND SCONCES IN THE READING ROOM. These splendid chandeliers and sconces are from the Edward Caldwell Company, highly skilled at light fixture design. That company, which has supplied the likes of the White House and the Waldorf-Astoria Hotel, built its fame on the ability to make fashionable the newly invented electric light bulb. Architect Albert Kahn probably directly commissioned the DAC's pieces.

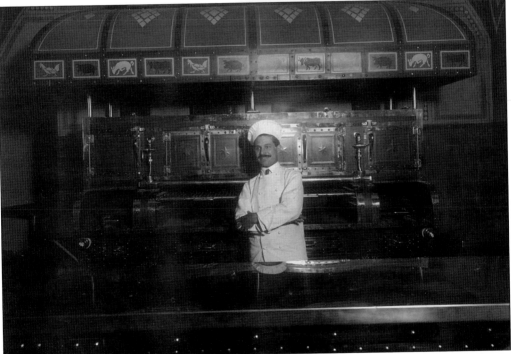

ANOTHER ART FORM IN THE EARLY DAYS OF THE CLUBHOUSE. The "Great Range" is shown here as it was in 1919. Now sadly gone, it occupied the area directly under the newest mural in the Grill Room. It was this massive grill oven that most likely gave name to the room. One can only imagine the splendor of the area with the gleaming copper-top counter in the foreground and the copper and brass pieces accenting the grill itself.

D·A·C· NEWS

OFFICIAL PUBLICATION *of* DETROIT ATHLETIC CLUB

DAC 60th ANNIVERSARY ISSUE

DETROIT ATHLETIC CLUB AT TWILIGHT (1919)
William Greason
American (1884-1945)
THE DETROIT INSTITUTE OF ARTS
GIFT OF D.J. HEALY (1922)

A P R I L , 1 9 7 5 O N E D O L L A R

THE "DETROIT AHLETIC CLUB AT TWILIGHT." Detroit painter William Greason's work was not commissioned by the DAC. Greason, who had a studio at 1500 Broadway Street, just a few hundred feet from the DAC, probably had this view from his studio. Greason attracted the attention of D.J. Healey, a prominent Detroit retailer, who then offered it to the DIA as the first contribution in its new building. In 1994, the painting was acquired and presented to the DAC by its Executives Club.

Seven

THE STAFF
OF THE DAC

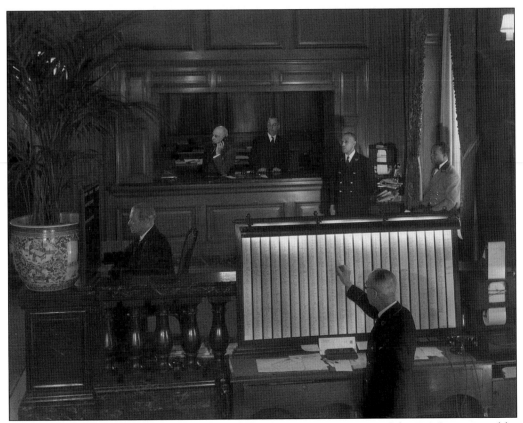

UPON YOUR ARRIVAL. The registration desk and the front entrance of the DAC were run like a military command post in years gone by. This image, taken sometime in the 1930s, shows Club staff ready to serve members' needs. The large lit board shows a list of all the members so that staff could check in (by putting a pin by each name) and know exactly who was in the building and even at what meeting or activity.

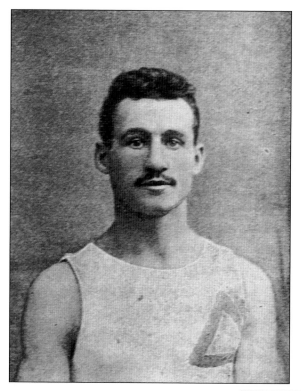

ONE OF THE FIRST ATHLETIC STAFF MEMBERS. Not much is known about John Collins other than the fact that he was 25 years old when he was made an athletic trainer at the first Detroit Athletic Club on Woodward. He apparently was a self-taught natural athlete who specialized in boxing and fencing, and helped Fred Ducharme train for hurdles races.

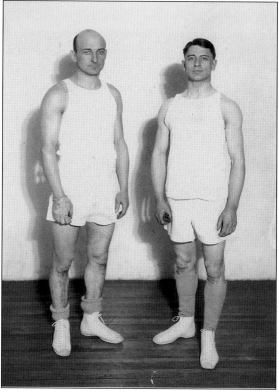

AN EARLY FITNESS TRAINER AT THE DAC. Another early athletic trainer at the new clubhouse on Madison was E.V. Tomlinson, seen on the left with another man only identified as "Henry." Tomlinson apparently "presided over the gym" for a number of years. They appear to be dressed for a handball match (note the glove on Tomlinson's hand).

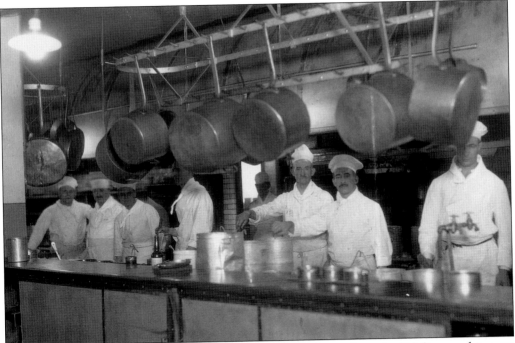

BEHIND THE SCENES IN THE KITCHEN. This rare photo from when the DAC opened its new clubhouse on Madison Avenue shows some of the kitchen staff hard at work in the main kitchen. Most of the cooking pots and pans were copper. The image was provided by the Walter Reuther Library Archives at Wayne State University.

ANOTHER GROUP FROM THE KITCHEN. This is also a unique photo from the Walter Reuther Library collection, showing some of the DAC staff around the time of the new clubhouse's opening. These ladies were from what was known as the "pantry" staff (the unknown woman in the center was in charge of this group). Note the giant gas-heated coffee urns at left. These workers were likely living in the employee quarters next to the Club on Cross Street.

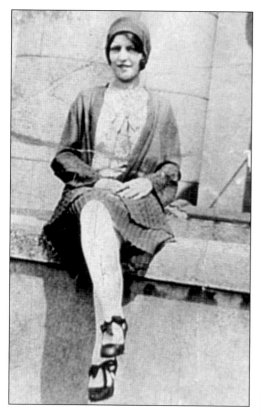

DRESSED TO THE NINES. This unusual image was taken from a copy of a duotone image given to the *DAC News*. The young lady's name is Anna Bujak. She is sitting outside of the DAC sometime in 1929. Bujak (showing plenty of legs in this photo) was known simply as a "salad girl" at the Club. Nothing else is known about her work at the Club.

A 25-YEAR VETERAN. Ann Sandusky had been a 25-year veteran of the DAC when this photograph was taken in 1940, as part of the silver anniversary issue of the *DAC News*. Sandusky, a DAC housekeeper, was one of 10 employees recognized for their service since the opening of the new clubhouse.

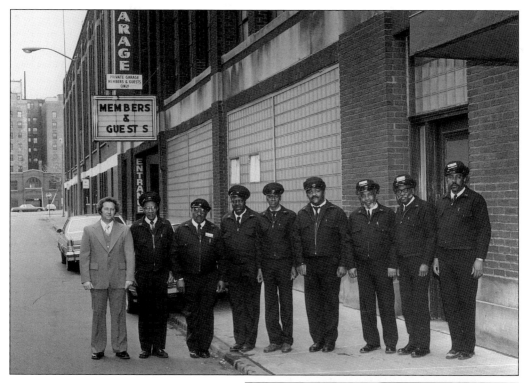

PARKING IS CRITICAL AT A DOWNTOWN CLUB. Being a downtown club is always a challenge, even for the DAC. One of the biggest issues over the years has been parking. These unnamed DAC employees from 1979 hurried to get automobiles using a tiny, exposed elevator cut through the floors. They provided important services to members at the DAC garage. Note the sign behind them that states "private garage, members and guests only." This building, constructed around 1920, has since been replaced with a modern facility.

HE OPENED THE CLUB BARBERSHOP. L.C. Fiddler, head barber at the DAC, shaved the first Club member ever to use the barbershop in 1915. This image was taken for a story about the updated barbershop in a 1937 *DAC News* article. The new shop replaced the original located on the first floor of the clubhouse.

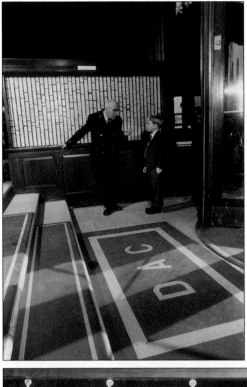

BELOVED DOORMAN. Howard Wickison, who worked at the DAC for more than 40 years, retired in 1974. He was beloved by members young and old alike, including this lad identified only as "little boy Gillis" in an image from the 1960s.

AMONG THE DAC'S FINEST. These employees served as DAC bellmen in 1946. From left to right, they are: Harry Cladwell, Nelson Stallsworth, Ellis Johnson, Charles Perry (he's the captain in the center of this image), Walter Winfrey, Theron West, Stanley Scott, Kenneth Sharp, and Clarence Woods.

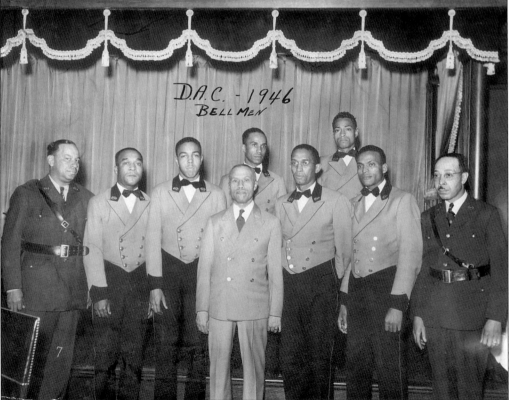

THERE HAVE BEEN ONLY TWO. Rex Aubrey, seen here in 1962 after being "dunked" in the DAC pool, became only the Club's second athletic director in its history at the new clubhouse. The young Olympic swimmer from Australia retired from the Club at the end of 2001, having served nearly 40 years. Clarence Pinkston was Aubrey's predecessor.

GREAT FOOD MADE BY GREAT CHEFS. Current DAC Executive Chef Kevin Brennan sits in this 1995 photo surrounded by other DAC chefs of the past. It was taken at a special dinner event called the "Great Chefs of the DAC." Behind Brennan, from left to right, are: former garde manager Jeff Gabriel, former pastry chef Otto Turb (1968–95), former executive chef Milos Cihelka (1968–75), and former executive chef Daniel Hugelier (1975–83).

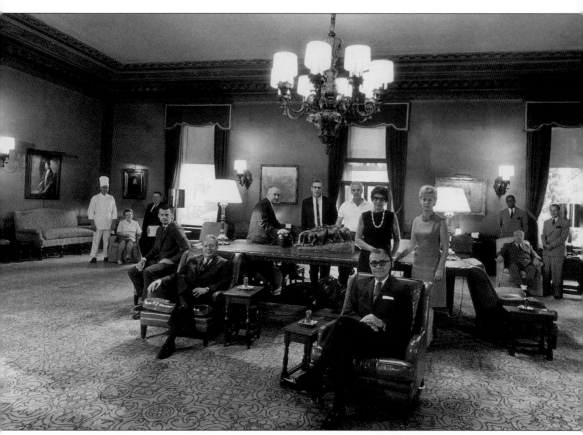

THE DAC EXECUTIVE STAFF OF 1967. This unusual image for a *DAC News* roster issue was taken of some of the executive staff in the clubhouse Reading Room. Pictured here, from left to right, are: assistant chef John Peterson, housekeeper Clara Kuehnholz, steward Fred Erdmann, night assistant manager Jack Pechette, comptroller Robert Stocker, bowling alley manager Eddie Wagner, athletic director Rex Aubrey, resident squash pro Joe Krinock, assistant secretary Marian Marshall, executive manager Richard H. Campbell (sitting center), secretary to the manager Virginia Olson, captain of the waiters Earl Robinson, supervisor of services Glad Wilson, and Norman Bondy (in charge of third floor service). Many of these administrative positions still exist at the Club, along with a number of new roles. Note the Caldwell chandelier and the paintings, many of which continue to hang in the Reading Room.

Eight

POST-WORLD WAR II AT THE DAC

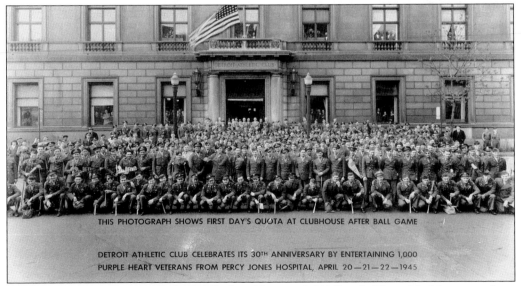

THIS PHOTOGRAPH SHOWS FIRST DAY'S QUOTA AT CLUBHOUSE AFTER BALL GAME

DETROIT ATHLETIC CLUB CELEBRATES ITS 30TH ANNIVERSARY BY ENTERTAINING 1,000
PURPLE HEART VETERANS FROM PERCY JONES HOSPITAL, APRIL 20—21—22—1945

APRIL OF 1945. That month the DAC played host to 1,000 Purple Heart Medal winners from Percy Jones Hospital. The men were apparently taken to a baseball game at Briggs Stadium and given toy bats. These were momentous days. President Roosevelt had just died eight days earlier, and the nation was still in shock. Untested Harry S. Truman was president. The war raged on in Europe, and Hitler would hold on for another 12 days before committing suicide, in effect ending the war there.

THE DAC'S ABBEY IN 1945. The Abbey is seen here filled with the fun-loving bowlers. It was a good time to celebrate. The war ended with total victory for the United States and her allies. Detroit, which had been producing war goods night and day, was preparing to swing back to producing cars and trucks to meet the nation's pent-up demand after four years without civilian vehicle production.

BOWLING LANES REBUILT. During the summer of 1967, while other clubhouse restorations were going on, the DAC's bowling lanes that had been completely rebuilt in 1949, were refinished. In this picture, Bill Pioch, DAC Bowling Chairman, and Manager Eddie Wagner take a close look at the finished work. Note the modern automatic Brunswick pin setters. For many years the DAC, and every other bowling establishment, relied on "Pin Boys" at the back of the lanes to manually re-spot the pins.

APARTMENT BUILDING KNOCKED DOWN. In 1995, the DAC demolished a decaying old apartment house near the entrance to the Club. That achievement was one of a series of major accomplishments by new manager J.G. Ted Gillary, shown here at the far left. To the immediate right of the wrecking ball is then-Club president William Morrow. Over the next few years, the DAC would undertake a major renovation program to keep the clubhouse in step with current needs. Also pictured are Bill Manion and Charlie Bayer

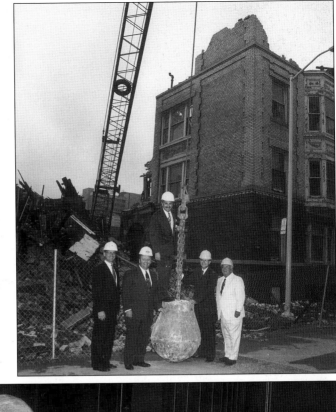

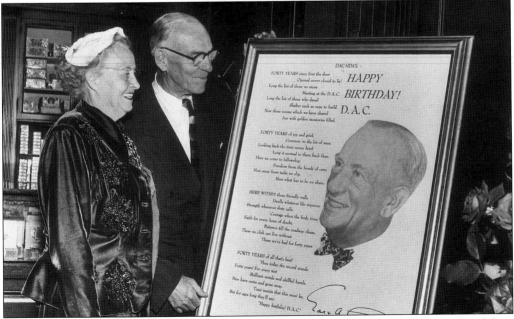

POET LAUREATE OF DETROIT AND DAC. Edgar A. Guest wrote a special poem for the club to help celebrate its 40th Anniversary in 1955. The framed work, on display in the main lobby, is here admired by Mr. and Mrs. Ben R. Marsh. He was the head of Michigan Bell Telephone Co. That same year was a celebratory year for Detroit, too; the auto industry was still booming and the Korean War was ending.

RANDOLPH SIDE ENTRANCE ABOUT 1950. One can see the Club's old parking garage with its Texaco sign evident. At one time, the Randolph entrance was assigned as the entry point for ladies. That rule was abolished years ago. The Club, in fact, in an early (*c.* 1914) newspaper story, reported that women could join the Club if they met the same requirements as male applicants.

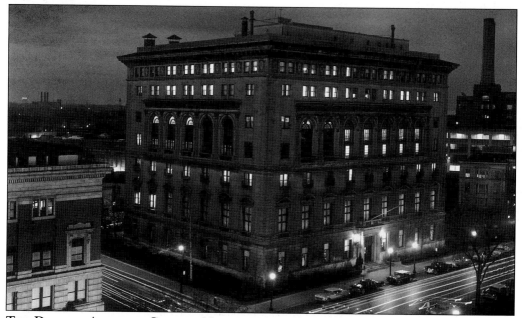

THE DETROIT ATHLETIC CLUB AT NIGHT. Here's the DAC in the late 1950s—the top two floors contain hotel rooms for members and guests and the editorial and advertising offices of the *DAC News*, in continuous publication since 1916. While the outside of the clubhouse looks much the same today, the inside has undergone careful restoration that kept the essence of the Club intact while updating its infrastructure.

Nine

REBIRTH AND RESTORATION OF THE DAC

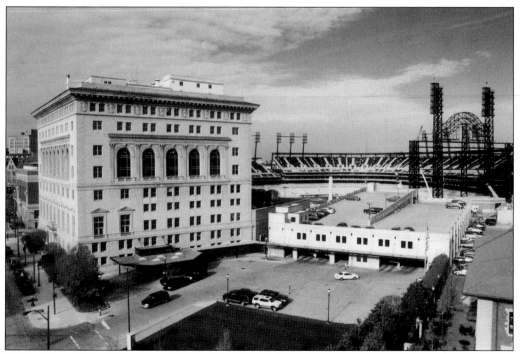

AT THE CENTER OF IT ALL. Here is the DAC in 1999, as seen from the rooftop of the historic Music Hall across the street. Construction on the new stadium for the Detroit Tigers (named Comerica Park) is nearing completion in the background. Just to the right will be the location of the new stadium (named Ford Field) for the Detroit Lions football team. The Club's own garage was dramatically expanded shortly after this image was taken.

DAC 2000 RESTORATION PLAN. The DAC's Main Lobby nears completion as workers fully restore and renovate the grand space in the summer of 1998. The multi-million project focused on the cleaning of the clubhouse's magnificent ceiling, bringing out the beauty of the original colors.

RESTORED TO GLORY. Some of the DAC 2000 management team makes one of their final inspections of the Main Lobby. In this image, from left to right, are: DAC engineer Bruce Baka, project supervisor Carmen Alampi, Terry Keating (first vice president of the DAC), Tom Quilter (DAC president at the time), and executive club manager J.G. Ted Gillary.

MAIN DINING ROOM WORK UNDERWAY. The beautiful A. Duncan Carse decorative paintings are visible again in this image of the restoration work in the DAC's Main Dining Room. The wonderful ceiling murals had been covered up for more than 20 years when the DAC 2000 restoration project got underway. The project focused on conserving the original artwork as well as restoring the entire room to its original glory.

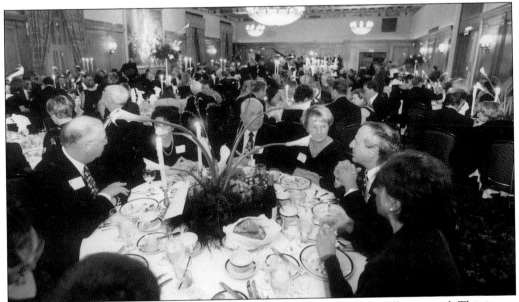

ALIVE WITH THE SOUNDS OF THE DAC. The Main Dining Room is fully restored. This image was taken during the DAC's annual "Back to the Club" night in September of 1999, and gives a wonderful perspective on the way the room looks at the end of the 20th century. Note the chandeliers and the large painting, known as *The Masquerade*, on the wall in the background.

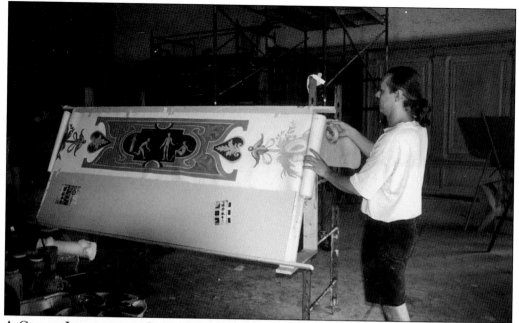

A CLOSER LOOK AT THE CARSE PAINTINGS. A member of the conservation team rolls out a stencil of one of A. Duncan Carse's whimsical motifs in the summer of 1998. The wonderful paintings were hidden under several layers of ordinary brown paint. DAC painter Wayne Woodard first discovered them—the plan originally called for refurbishing the ceiling as it was, but that all changed after Woodard discovered the original works still hidden underneath.

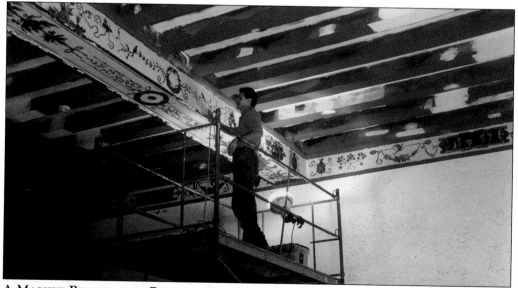

A MASSIVE RESTORATION PROJECT. A conservation team member inspects some of the work done to the main crossbeams. At the time of this photograph, much of the ceiling was still to be uncovered. Once uncovered, stencils were made and repairs begun to the paintings. Over the years, the Main Dining Room had suffered constant water damage. The solution was to paint the ceiling a bland brown. Ironically, a water leak in 1997 led to the rehabilitation of the dining room and the ceiling treasures.

124

THE READING ROOM UNDER RESTORATION. The DAC 2000 restoration included work in the Reading Room on the first floor. The beautiful Caldwell chandelier (taken down in this image) was fully restored along with the massive wall scones. The gold ceiling trim was fully cleaned as well as restored. In this image, workers replace the wall fabrics.

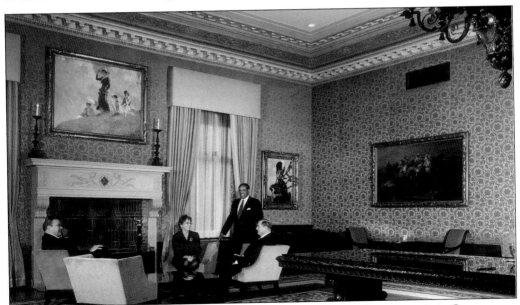

THE DAC'S ARTISTIC SHOWCASE. This is the Reading Room after restoration. One can see part of the Caldwell chandelier. Also, the carpeting is a custom-created DAC signature carpet. Note the beautiful marble fireplace, also restored during the project, and the paintings hanging on the wall. The massive oak table in the center of the room is also original to the Reading Room (compare this photo to the one on page 33).

PHASE TWO OF DAC 2000. The second phase of the multi-million dollar restoration of the DAC began in 1999, and focused on restoring and expanding the Grill Room, improving the main clubhouse kitchen, and adding a new kitchen just for the Grill Room. This image from the summer of 1999 shows the room before workers have polished the Pewabic tiles on the floor and prepared the ceilings for restorative painting.

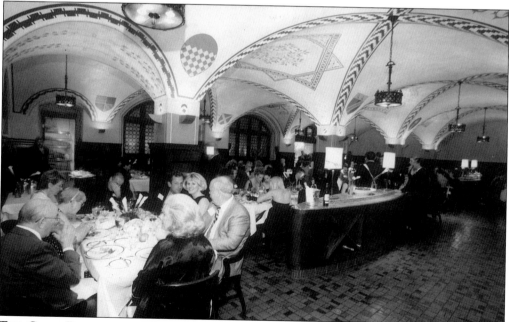

THE GRILL ROOM IN THE FALL OF 1999. This is the grand and elegant Grill Room fully restored during the "Back to the Club" party in September of 1999. Note the stenciled arches of the ceiling (replicating the original Carse paintings) and Pewabic tile floor. This is known as "the Bricks" side of the Grill Room. The dining area also includes "the Carpet," where members can dine in quiet elegance.